P9-EAJ-019

Douglas Hall

MODIGLIANI

PHAIDON

Phaidon Press Limited, Littlegate House, St Ebbe's Street, Oxford
Published in the United States of America by E. P. Dutton, New York

First published 1979

© 1979 by Phaidon Press Limited

ISBN 0 7148 1966 2
Library of Congress Catalog Card Number: 78-24733

Printed in Great Britain by Morrison & Gibb Ltd, Edinburgh

MODIGLIANI

Modigliani is nowadays a popular artist. The subject-matter of his painting is limited and easily understood, consisting almost entirely of portraits and nudes. His style is easily recognizable. For those who wish to go a little below the surface and find in him a true pioneer of modern art, there are his austerely beautiful but primitivistic sculptures, while his drawings satisfy the eye with a virtuosity that modern art often withholds. His bohemian life in Paris gave rise to a legend, true in basic particulars, which makes him, almost as much as Van Gogh, a type for the artist at odds with society. His life was short, as an artist's life must be for his story to be seen in simplicity and bright colours. Born in Italy in 1884, he came to Paris at the age of 21, and died, of tuberculosis aggravated by alcoholism and drug-addiction, in January 1920, aged 35. Neglected as long as he lived, it is reported that at his funeral dealers were negotiating a new price-level for his paintings.

Modigliani can seem a very different figure, according to which kind of literature one reads. To the critical writers of the more aesthetic kind he is ethereal, elevated, a profound psychologist. To the writers of anecdotal biography he is interesting because of his excesses with women, alcohol and drugs, and his scandalous behaviour generally during his last few years of life. It is doubtful whether a satisfactory historical account of Modigliani can now be written, since no new sources are likely to be tapped. Few people are still alive who knew him personally. The dealings of the Paris art world in Modigliani's time there (1906–20), a time when many reputations and fortunes were being made, have always been impenetrable to enquiry. The situation is not very different for other artists of the School of Paris who were not successful enough to attract chroniclers and cataloguers at an early stage, as Picasso did; or who belonged to the underworld of art, like Utrillo, Soutine or Pascin, and Modigliani himself.

This underworld of art in Paris is a phenomenon which has not received the scrutiny which it deserves from the psychological and sociological points of view. For the present it can only be described in the baldest terms. This was the phenomenon from which came a group of artists, including Modigliani, who were dubbed *les peintres maudits*. 'Accursed painters' rather than 'damned painters' would be the better translation of the term; it implies that they were in some way fated, not merely a nuisance. No doubt they were considered to be both. The elements that made up the situation of this group were alienation, poverty, weakness – and brilliance. Most of them were foreign, and for all that Paris beckoned aspiring foreign artists, it did not welcome them. If they were not only foreign but disadvantaged by being for example Jews, or of the peasant class, or from outlying parts of Europe, their isolation from Paris was assured. Their poverty goes without saying, and what might be called the poverty trap, whose other jaw is alienation, duly closed on them. No doubt hundreds of artists coming to Paris were caught by this trap and left no record of success or failure. Conversely some of the most famous names in modern art came to Paris under such disabilities – typically they were poor Russian or Baltic Jews or East Europeans. Chagall, Lipchitz, Zadkine, Brancusi are examples. They overcame alienation, lived through poverty to success and acceptance, and did not become *peintres maudits* (or *sculpteurs maudits*). For that the third element was necessary – call it weakness, or an inner disposition to succumb.

The last element to make up the *peintres maudits*, brilliance, was necessary to their historical survival. For although there were good and less good artists among them, none received attention without achievement. What was the connection between their achievement and the disorderly lives they led? That is the interesting question. Their phenomenon was not quite a new one. The exceptional nature of artists has often been stressed, and this has included eccentricity, sexual deviance, political dissent, social unacceptability, madness feigned or real. The peculiarities of artists came into prominence at romantic periods. Yet for romantics, realists and abstractionists alike, poverty and alienation came from being ahead of the taste of those who might support them. And from this came also the possibility of speculation in their works. The artist as deviant might become the artist as celebrity. By the time Modigliani came on the scene, speculation in contemporary art was well established, owing to the precedent set by the Impressionists. The new element in the twentieth century which increased the opportunities for speculation was the recognition and appreciation of neurotic art. As the appetite for originality and intensity of expression grew, it was increasingly recognized that these qualities could not come from skill or experience alone, or from the lives of normal members of society.

How did Modigliani, who was not uncultured, primitive, boorish or really poor, and who spoke perfect French, become a member of this ill-starred group? Why did he find his closest friends in Soutine, the slovenly and dirt-poor Baltic peasant who cared for nothing but the act of painting, or the simpleton Maurice Utrillo? These questions can never wholly be answered, as Modigliani's biography can never be wholly complete. We can only find tentative answers in his background and heredity as they reacted with the Parisian situation. The new climate of speculation in artistic reputations already noted, carried on with the characteristic entrepreneurial ruthlessness of the time, was one factor in this situation. Within a short time of Modigliani's arrival, some of his own generation were already benefiting from speculative attention. They were the strong characters, pre-eminently Picasso. For the weak-minded, speculation was likely to take the form of sheer exploitation or calculating neglect. It seems to have been the latter that wounded Modigliani particularly. Although weak in a sense, he would have been intolerant of obvious exploitation.

The other element in the Parisian situation that was necessary to Modigliani's tragedy is more strictly a matter of cultural history. The cultural atmosphere of Paris, as elsewhere in Europe at the turn of the century, was determined by the literary and artistic movement of Symbolism, which encouraged an intense subjectivism and intolerance of norms, extending, at least on paper, to conduct and lifestyle. The gap between art and life had become an increasingly dangerous territory during the nineteenth and twentieth centuries, and by his conditioning and his self-destructive character-traits Modigliani was predisposed to fall into it. He was the victim of a confusion between the two and of an immature self-deception about the role of artists. Fortunately Modigliani's youthful background is quite well documented, so that one may understand up to a point how he came at last to attract the term *maudit* – that ironic pun on his shortened name.

Amedeo Modigliani was born at Leghorn on 12 July 1884. He was the youngest of four children of Flaminio Modigliani and his wife Eugenia Garsin. The family was impoverished at the time of Amedeo's birth and had never, contrary to legend, been more than moderately prosperous. Both his parents were Jews, but of different traditions. Eugenia Garsin came of a line of Spanish Jews settled for four generations

in Marseilles, austere but liberal in their attitude to religion, philosophy and culture. Flaminio Modigliani came of strict Italian Jews from Rome, but seems to have been a weak man, who counted for little after his business failures in the year of Amedeo's birth. His frequent absences were perhaps little noticed, as the household and family was an extended one and included, besides the four children, Eugenia's two sisters, and at times her father and her maternal grandmother. Eugenia was the real head of the household and often the breadwinner.

The chances were that the youngest child in an extended Italian family would be spoiled, but there were also malign indications in Amedeo's environment and heredity. His grandfather, with whom he spent much time, an aunt and a sister all suffered from feelings of persecution. Amedeo's grandmother Regina died of tuberculosis. His aunt Gabriella committed suicide in 1915. His uncle, after whom he was named and who paid for his travels, died in about 1905, a mercurial man doomed to unhappiness. Eugenia was the kingpin of an intensely feeling and self-destructive family. When Amedeo himself showed the first signs of physical weakness, his mother brought all the force of her overwhelming maternal attention and affection to bear on the young boy. He remained a mother's darling into his teens. We first hear of Amedeo (Dedo to his family) in his mother's diary as 'a little spoiled, a little capricious, but *joli comme un coeur*' at the age of two. His good looks were to remain a byword for the rest of his life. In 1895 he frightened his mother with an attack of pleurisy. She writes of his unformed character, his temper and his intelligence. In 1897 Eugenia wrote that Amedeo 'already sees himself as a painter', and was about to start drawing lessons. It was a way out, she thought, from the apathy and sadness that seemed to beset the whole family. Unfortunately more trouble was to come. In the summer of 1898 Amedeo fell ill with typhoid fever.

The attack of typhoid in 1898 was a turning point in Amedeo's life. Narrowly recovered from it, he was allowed to give up school and join the studio of Guglielmo Micheli, a Leghorn painter who was a late representative of the *macchiaoli* school of Italian *plein-air* painting. But illness soon struck him again; in 1900, probably in September, he again contracted pleurisy and this time was left with the tuberculosis which, even more than drink or drugs, contributed to his premature death. But for the time being he recovered, and we feel that it was Eugenia's intense maternal solicitude that pulled him through. When he was better she took him on a tour in the south of Italy. They went to Naples, Capri, Rome, Amalfi, then north again to Florence and Venice. Once broken out of the limits of Leghorn, Amedeo soon left home again by himself. On 7 May 1902 he enrolled at the Academy of Fine Art in Florence, in the class of the respected Leghorn *macchiaolo* Giovanni Fattori, but on 19 May 1903 he was to enrol again for the same course, only this time at Venice.

Modigliani seems generally to have pleased his teachers as a young man, but nothing is known of his performance at the Academies of Florence and Venice. The chronology of his life between his first break from home in 1902 and the bigger break to Paris in 1906 is obscure. Probably he attended the classes seldom. At this stage, when his works could be expected to come to the aid of the story, we find that almost nothing has survived. Whether he himself destroyed it is not certain. It is quite probable that he actually produced very little then. The very intensity of his professed passion to work perhaps made it difficult to get down to it. But there was another, perfectly genuine reason for his painting little. Modigliani had decided to be a sculptor. An undated postcard from Pietrasanta, the marble-working town near Carrara, asks his friend Romiti to arrange for enlarged photographs of a sculpture.

This card was dated 1902 by Romiti. So Modigliani, who had scarcely broken away from his mother's apron-strings and was supposed to be enrolled in the life school at Florence, had taken lodgings at Pietrasanta and produced a carving of which he was proud. This sculpture cannot be identified, and the photograph has not been found. After this – to the confusion of his family, who had scarcely got used to his vocation as painter – he proclaimed himself a sculptor. If Modigliani produced many more paintings than sculptures, it was because he was often too ill to carve stone, which raised dust, or he had no room or materials. Also, many of the carvings he managed to produce have been lost or destroyed.

Modigliani's early love affair with sculpture indicates his independence from his Italian contemporaries and teachers. It has been said that Modigliani's true teachers were the old masters he saw in Rome, Florence and Venice. He did not speak of the sculptures he saw there, but his own sculpture leads us to suppose that he admired medieval rather than Renaissance sculpture. The influence of primitive sculpture that he encountered later in Paris was grafted on to this. But Modigliani's fellow-students in Italy must have been an important influence on him. One of them, Oscar Ghiglia, cannot be omitted from even a short account of Modigliani's life. Ghiglia was eight years older, and Modigliani's sister, admittedly a prejudiced source, indicated that Ghiglia was a bad influence on him, and the first to introduce him to drugs. (According to an even more precocious youth who knew Modigliani in Venice in 1903, he was at that time taking hashish.) However, Ghiglia's importance to our understanding of Modigliani is in the letters Amedeo addressed to him from his travels in 1901, which show that the influence was not all one way.

Modigliani's five letters to Ghiglia are almost the only statements of his that have survived, and they give a good picture of the state of his mind. Art, life and work jostle each other in these febrile, boyish letters. He confesses to 'a tumult of beautiful images and antique voluptuousness in my spirit' (with a sidelong hint of erotic adventures); and feels 'the prey of strong forces that are born and die in me'. He remarks self-consciously to Ghiglia, ignoring the age difference between them, that they had parted 'at the most critical moment of our intellectual and artistic development'; but when Ghiglia eventually replies in a state of depression, Modigliani tells him 'your real duty is to save your dream'. There are also sentiments which show a solid perception of the artist's job. He promises to dedicate himself faithfully 'to the organization and development of every impression'. He understands the need to reveal and rearrange what he calls the 'metaphysical architecture' of his ideas and experiences and to await their natural gestation. It is in the last letter to Ghiglia, written in desperate response to his friend's trouble, that he clearly reveals the ideas that were to determine his own future. 'People like us . . . have different rights from other people because we have different needs which put us – it has to be said and you must believe it – above their moral standards. Hold sacred . . . everything that will stimulate and excite your intellect.' And with supreme irony: 'the man who cannot . . . as it were create new personalities within him to fight always against the worn-out and rotten, is not a man.'

This is pretty pure Nietzsche. But it was not only a matter of Nietzsche. Modigliani had received a good literary education at school and at home. He must certainly have been aware of the literary cult of depravity, which was supposed to produce the finest flowers of symbolist poetry. One of its extremest manifestations, *Les Chants de Maldoror* by the self-styled Comte de Lautréamont, was a well-thumbed possession of Modigliani's. This nightmarish, sadistic and irrational book was to become a source

for the Surrealists after Modigliani's death. Yet Modigliani's work is not at all troubled by premonitions of surrealism, or much affected by memories of symbolism. He took the drug of *Les Chants de Maldoror* as he took other drugs, directly.

Thanks to the impression he made on the memories of his family and friends, his letters to Ghiglia, and a few other sources, it is possible to form a reasonably complete picture of Modigliani as he was on arrival in Paris in 1906. There was still about him much of the pampered, self-willed child of a weak father and a strong mother. His illnesses had made him the centre of morbid attention, and had probably ended by impressing on his mind an idea of fatality. His family history was full of physical and mental disability and he already carried this liability in his own body and mind. His appearance was striking, his manners were elegant and rather lordly, though tempered by a recurring shyness – at least when he was sober. He was an instant success with most women. His ideas were large and his talk was even larger. He was given to fantasy. Some of the myths that circulated about him were probably propagated by Modigliani himself; certainly those that concerned his family came from him, namely that his mother was descended from the philosopher Spinoza and his father from rich bankers who had lent money to Popes. His pride was great, especially with regard to his race. He would introduce himself: 'Je suis Modigliani, juif', and was quick to resent any hint of anti-semitism. He had lived with highly intelligent and over-sensitive people whose minds were open to the bewildering mixture of philosophical, literary and political ideas of the late nineteenth century, in which Nietzschian irrationalism and glorification of the superior individual mingled with literary symbolism and political socialism.

So much for his traits. When we come to his artistic formation at that point, the picture is much more vague. But certainly, Modigliani's world so far had offered him no visual counterpart to the ideas just described, and he was never to find one. They issued in his talk and behaviour, leaving his work stamped with his personality, unavoidably so, but not with his ideas. What determined the form of his work was his own conception of a style, grafted to what he had absorbed of Italian art and reared in the forcing-house of Paris.

In the heady atmosphere of Paris, Modigliani never submitted to the influence of anyone except, in the most general sense, Toulouse-Lautrec and Cézanne; never of his contemporaries. That is the positive side of his intense pride. But his pride was also the cause of the decline of the beautiful young Italian into a drunken, quarrelsome braggart and failure. The plain fact is that when success did not come, Modigliani was too proud to change his course, to look for another way of maintaining himself, or to husband his small resources. Not knowing which way to turn, and committed by his Latin nature to life as a series of confrontations with others, he was forced to adhere ever more stridently to the poses he had struck, which became ever more hollow and debilitating. So fantasy turned to bombast, larking to destructiveness, and pride to morbid touchiness. The manifestations of this process have provided most of the material for his biographers. This would be justifiable if the incidents described threw any light on his work. Mostly they do not. It is no surprise that the biographical and critical studies of Modigliani are so far apart, as it is so difficult to bring his life and his work into focus together.

Modigliani arrived in Paris in January 1906. For some weeks he lived in a comfortable hotel, but soon gravitated towards the two artists' quarters of Montparnasse and Montmartre. Aware that he had still a lot of learning to do, he enrolled at the

Académie Colorossi. The first evidence of any work done refers to 'the winter of 1906', when a compatriot saw some heads of women in a little gallery run by an Englishwoman on the left bank. From their description it is evident that they were symbolist paintings slightly in the manner of Carrière. Two if not three of these were in the Alexandre collection. It was in the autumn of 1907 that Modigliani met his first, almost his only private patron, Dr Paul Alexandre. Thanks to him, some twenty-five early paintings and numerous drawings have been preserved, though never fully published.

Paul Alexandre was not much older than Modigliani himself. He lived with his father and his brother Jean, with the latter of whom he had set up a free house for artists at 7 rue du Delta. Alexandre seems to have favoured Modigliani most among the artists who came to the rue du Delta, although he was probably the most troublesome. The story is that he was eventually barred from the colony for the worst of crimes in such a society – destroying the work of another artist. That did not prevent Paul Alexandre, in old age, from remembering him as 'a very well brought-up young man'. In a sense he was. He was also a fascinating medical case, both mentally and physically – a walking casebook of the parapsychology of creation. Alas, if Alexandre ever regarded him in that light and made notes, they have never been published. He himself was 'of the movement', believed in hashish taken in moderation, and shared in the passionate vogue for primitive art. While he knew Modigliani, the latter was still high-spirited rather than violent, and still able to adapt himself to bourgeois deportment, as he had to, for he painted the dignified father as well as both sons. Later on, when the violent oscillations of Modigliani's behaviour were destroying him, Dr Alexandre had gone to the war, then married and lost touch with his bohemian protégés.

It is possible that the 'bloodless heads of women' seen in the Englishwoman's gallery were done in Italy, though they resemble the work of a French symbolist. There can be no such doubt with the group of paintings centred round the Alexandre portraits (Plates 1, 6 and 7). They are completely of Paris, and show above all the influence of Cézanne mingled with that of Toulouse-Lautrec. From Cézanne come the unifying pattern of brushstrokes, the diagonal *passage* across the canvas; from Lautrec the biting delineation of character through the drawing of features. The influence of Picasso, who himself had drawn heavily on Lautrec, is more problematical. There is evidence that Modigliani was a little obsessed by Picasso at this time and knew that his own work resembled the Spaniard's but was still inferior to it. Adapting to the new light of Paris had also given him new ideas on colour, owing something to the *fauves*.

The truth is that Modigliani's work at this time was highly experimental. His taste was forming – he still admired Sargent and even Boldini, slickest of society portraitists, even while he was jealous of Picasso. Consider the early works reproduced in this book. *The Amazon* (Plate 7) is a would-be society portrait whose mordancy comes from Lautrec. Other works, which must be near in date, ignore the study of personality in favour of Cézannian study of volumes. Earlier than these is a group of Lautrec-like, somewhat expressionist works all showing the same model, a severe-looking, statuesque Jewess (Plate 6). Perhaps the finest of the paintings datable to the early Paris period is the magnificent portrait of Pedro, 'the printer', a work of great solidity and penetration of character (Plate 1).

What of his sculpture at this period? It is impossible to say. But scattered among Modigliani's paintings are a handful in which painting and sculpture draw close

together. One of a young girl (Ceroni I, 9; see Bibliography on p. 15) is as early as 1908. The body is remarkable, but painterly – it is Matisse almost before Matisse. But the stupid, pursed-up little face is rounded and polished like a marble. Moreover, here for the first time in painting is Modigliani's typical round, columnar neck. This neck was surely first evolved in sculpture, but when? The chronology of the sculptures is impossible to determine. There are many anecdotes about his sculpture, for example that he took a barrowload of heads to Dr Alexandre in 1913 (this in Alexandre's own account to Ceroni) and that he stole sleepers from the Métro, though there is only one wooden carving in existence, not universally accepted as Modigliani's work. The most convincing and tragic anecdote has it that on his last recuperative visit to Italy, in 1912, he obtained stone and shut himself up to sculpt, but that his friends did not appreciate the carvings and advised him when he left to throw them into the canal. It has been inferred that he did this; at any rate no surviving sculpture can be securely dated to this time.

However, a photograph (reproduced as frontispiece to Ceroni, vol. II) shows Modigliani standing by an unfinished stone head which is similar to our Plate 4. This photograph was most likely taken on his return to Paris, as his appearance fits with the one his Italian friends remembered from his visit. Possibly the sculpture was one he actually did bring back from Italy and finished in Paris. It rests on a bolted construction that could be a travelling crate. But before this he had had four elongated heads photographed in the studio of a friend in 1911. In the autumn of 1912 he successfully submitted no less than seven heads to the Salon d'Automne, where they were catalogued as *Têtes ensemble décoratif*. In Ceroni's opinion, *all* Modigliani's scuplture was executed in 1911–12. This seems impossible, although the evidence suggests many of them were done then. Plate 4 seems to belong to a different order of creative endeavour from the superb head in the Tate Gallery (Plate 14). This head is among the most perfectly finished, and is also the one in which the native Italian and the primitivist influences are most perfectly integrated. In this type of sculpture the features are fully part of the total form, while in many others, Plate 4 among them, they are on the surface only. It is tempting to think the Tate head later, but it was surely one of the ensemble exhibited in 1912.

Modigliani's sculpture deserves to be considered separately from the farrago of anecdote that surrounds his painting life. In it he was at his most serious, and his work has connections with the pioneers of modern sculpture even outside his immediate acquaintance, an acquaintance which, however, included Brancusi, Epstein, Archipenko, Lipchitz and Zadkine. Modigliani's 'decorative ensemble' is a reminder of the ambition of sculptors in the early modern epoch, when large schemes of sculpture on buildings were still quite usual. He dreamed of a 'temple' sustained by caryatids, exactly the same dream that seduced Mestrovic at the same time and which, thanks to Serbian nationalism, he was partly successful in realizing. Epstein, Brancusi and others also had their grand concepts which they were able to execute in some form or other. Here, as always, Modigliani was the unlucky one.

Modigliani probably did little more in sculpture after 1913. At all times he drew. The most well-known Modigliani of the legend is the handsome, tragic young man handing out drawings in cafés, for a few francs, for a drink, or for nothing at all. Modigliani drew in cafés from his first arrival in Paris, but probably not as a lifestyle until after 1913 or 1914. This may account for the impression of some witnesses that he had just started to draw. The few paintings datable to those two years are still very tentative, which is consistent with the belief that he had been concentrating on

sculpture. As if exploring the possibilities of a new medium, he produced in 1914 a remarkable pair of portraits in his most 'painterly' manner (Plates 16 and 17), with very little use of line and with dots of colour applied in a *fauve*, almost *tachiste* way, leaving much of the ground uncovered.

1914 was something of a milestone in Modigliani's tragedy. Discouraged with sculpture and often ill, he was launched on his brief, unhappy trajectory as painter. The war removed from Paris his friend Alexandre, as it removed the capable French members of the artists' circles, leaving the cafés to the foreigner, the unfit and the misfit. The chances of genuine sales were reduced, and the climate became even more favourable to the speculators. It was during the war that Modigliani found his only two dealers: Paul Guillaume (Plate 23) and Leopold Zborowski (Plate 35). Modigliani painted Guillaume several times, and wrote on one of the portraits the words *Novo Pilota*, the new man who would pilot him to fortune. Alas, Modigliani was never one to be piloted anywhere. Zborowski he painted often, sometimes as friend, sometimes as dealer and man of affairs.

By 1914, a form of watered-down cubism had become the dominant mode in advanced studios in Paris. Modigliani was jealous of this, but no doubt Guillaume and Zborowski would have been glad if he had painted them cubist pictures. In fact, 1915 and 1916 are often described as Modigliani's cubist period. *Celso Lagar* (Plate 20) and *The Couple* (Plate 21), one of his rare double portraits, illustrate how much or how little this is justified. Modigliani uses compositional diagonals and structural lines unconnected with outlines. He uses linear shorthand for features, and adopts a sub-cubist device of representing the nose in profile in a full face (Plate 21). These features may seem like a concession to cubism in a painter as individual as Modigliani, but in *The Couple* they result not in the rich and heavy weave of cubist painting but in a deft, witty comment almost in the manner of Klee. And the paintings reproduced from Plate 18 to Plate 24 show what a great range of emotional expression Modigliani could encompass in his so-called cubist works. These works include some of the least sculptural he did, as if, on the rebound from his intense involvement with sculpture, he was pushing hard into a new territory.

How much was he aided, in exploring this new territory of painting, by drug-induced euphoria? The legend has Modigliani under drugs suddenly discovering the 'right road' – i.e. drawing his first woman with a swan neck. This is palpable nonsense. The long neck was a sculptural device which appears in his painting at an early stage. It was by no means universal in the cubist period nor even became so later. It was not reserved for women; two of the most masculine sitters Modigliani ever had, Henri Laurens the sculptor (1915) and the stunt actor Gaston Modot (1918), have the longest necks. But admittedly Modigliani endowed the important women in his life with this attribute, and none has a longer neck than Beatrice Hastings (Plate 18).

Modigliani met Beatrice Hastings in 1914, just before the war. To his circle, she was 'the English poetess'; in reality she was a South African journalist, though she wrote poems. Modigliani and Hastings lived together in an extremely stormy liaison from 1914 to 1915 or 1916. His portraits of her show oddly little evidence of this. Occasionally, her *chic* and sophistication are hinted at, but never her termagant nature. Most often she is shown round-faced, small-featured, blank of expression (Plate 18). The wistful sadness of Modigliani's later portraits had not yet developed at this time. Perhaps such an abrasive woman as Beatrice could hardly be represented as wistful. Physically she suffered at his hands; probably she redressed the balance in

other ways. Modigliani's ritualistic, adversarial extremism demanded in others the right sort of response – it required the submissive woman, the complaisant friend, as a sort of counterpoint. Beatrice would not play, and by not doing so she perhaps gave his behaviour a dimension of real unpleasantness it did not have before.

Throughout his painting career the eyes in Modigliani's portraits are remarkable, and often he represents them as blank. This practice was most common in 1915 and 1916, and sometimes they are not only blank but criss-crossed with hatched lines (Plate 23). Modigliani told a young friend that these little diamond panes were 'to filter the light'. At the other extreme are eyes larger, more lustrous and penetrating than is perfectly comfortable (Plate 24). Yet whether or not pupils and irises are shown, the eye is always expressive. This is because of Modigliani's miraculous gift for composing the elements of the face. Whatever distortions are employed, whether the face is elongated, compressed, inflated or mercilessly pulled into a cruel simulacrum of some physical oddity, the features fall into place like the inside parts of a musical harmony. The unusually formal and complex portrait of Jean Cocteau of 1916 (Plate 22) marks a transition between the 'cubist' and the 'classic' periods in the type of distortion employed. The angularity of the drawing, the nose thrust ruthlessly into a profile position, the prominent cheekbones and pointed chin, favour a cubist interpretation, and are exactly suited to the razor-sharp intelligence and singularity of the sitter, while the formal clothes, square shoulders and high chair-back suggest the oracle and arbiter of taste, and belong more naturally to the 'classic' portraits.

In 1915 and 1916, with Beatrice Hastings and Paul Guillaume as his worldly mentors, Modigliani was perhaps near to 'success'. But as they were also years of increasing depression and aberration, not surprisingly success eluded him. Some time in 1916 the more bohemian and tolerant Zborowski took over from Guillaume the self-appointed task of promoting Modigliani's work. From then on Zborowski and his seemingly hard-boiled wife (Plate 31) were to guide his life and to be his only source of funds – his small allowance from home having ceased with the war. After his final break with Beatrice, the legend has him involved in many affairs. His liaison with Simone Thiroux, who bore him a child, seems to have been ended brutally by him. By contrast, his life with Jeanne Hébuterne, student and painter, from Easter 1917 to his death, was the nearest he knew to marriage. These were both quiet, complaisant women who adored him and were incapable of reforming him, or trying to. His relationship with the mysterious Lunia Czechowska, unusual in that it may not have been consummated, was then the only one on a level of intellectual equality. In her memoirs she claims that she temporarily reformed him. In 1918 Modigliani's state was so bad that the Zborowskis somehow arranged for them all to go to Nice. Jeanne Hébuterne had her baby there in November. In May 1919 Modigliani was better and returned alone to Paris, where, according to Lunia Czechowska, he enjoyed several weeks of calm life under her influence without drinking. Unfortunately, after Jeanne's return with the child, the vicious spiral resumed.

Modigliani's sexual life is of course a staple with his biographers, and may seem to find its visible expression in the catalogues with his series of magnificent nudes (Plates 26, 27, 36–39). It is in fact impossible to correlate Modigliani's legendary sexual history with the surviving nudes. There is no nude painting of Beatrice and no nude or portrait identified as Simone. Probably most of Modigliani's nudes are of professional models, whether or not they were paid. It is assumed or asserted by certain writers that Modigliani had sexual relations with all his models. This shabby

assertion seems to belittle the professionalism which he managed to preserve through all his vagaries. It assumes that he could not project his undoubted sensuality by generalization, without having immediate satisfaction from these particular women. The look on their faces, languorous, expectant or knowing, may seem to support the assertion. However, with some exceptions the nudes of Modigliani cannot be regarded just as portraits of women without their clothes. He was not aiming to depict sexual phenomena like Pascin. His ambitions were higher. Pascin and Foujita, his bohemian contemporaries, can never be seen as inheriting the grand tradition of the nude from Giorgione and Titian through Rubens to Boucher, Goya, Manet and Renoir. Modigliani can. On his one and only visit to Renoir he was apparently sickened by the old man's maudlin sensuality. His own was of a fiercer variety, but he was also more capable of distancing himself from the object.

It is his capacity to reveal general truth within the analysis of detail that makes Modigliani a major artist, and establishes his succession to the grand Italian manner. An interesting comparison is with Degas, who was able to extract a classical sense of permanence from the flux of contemporary life. Compared with Degas, Modigliani's life was disorderly, yet he began with an instinctive sense of order both in his narrow choice of subject and in his capacity to design a painting. The paradox of Modigliani is that his classicism was finally reached only during his last three years of declining health and sanity.

Not much more need be told here about Modigliani's life. His recovery in the summer of 1919 did not last, and Lunia failed to persuade him to accompany her again to the south. He played with the idea of returning to Italy, saying reportedly 'only Maman knows what is good for me'. But he did not go, any more than he heeded the pleas of Zborowski and others to have treatment. The impression is inescapable that Modigliani wanted to die. The accounts of his roaming the streets of Paris, drunk or soaked through, in his last weeks, vie with each other in their tragic pathos. On 22 January 1920 he was taken to hospital in a coma and died two days later. The following day Jeanne Hébuterne threw herself from the window of her parents' apartment and died. She was then about seven months pregnant.

It is against this sad background that the last two styles of Modigliani must be seen. Compared with the portraits of Cocteau or Guillaume, a new tranquillity can be seen in the *Head of a Girl* (Plate 34) or the *Portrait of Victoria* (Plate 30). These images are enclosed in a firm but flowing outline, within which the features and details of the face, hair and clothing are developed in a more integral way, in a way less concerned with surface drawing than with coherence of detail within the general form. The placing of the figures within the canvas and their own postures tend to be more relaxed at this period than before. The influence of Cézanne re-asserted itself in 1918; perhaps it was part of the effect of Modigliani's year in the Midi. In Plate 40 it is particularly marked and, as here, it goes with a tendency to treat certain sitters like still-life (which he never painted). Plate 40 represents a new category in his work – a sitter who was neither a patron, a model, nor anyone in Modigliani's circle. Such subjects had the effect of reinforcing the classicism of this period, as they could more easily be generalized. An extreme example is *La Belle Epicière* (Plate 42), where Modigliani's new classic format – sloping or rounded shoulders merging into long neck with small or narrow head – is reduced to its simplest essentials, and the girl's face is hardly characterized at all. Some of the pictures of this classical phase use this generalization to produce an air that is poised and elegant, and breathe a sense of ripeness and satisfaction that belongs to the south. Yet this did not rule out a

sharp observation of facial peculiarites when required, as in the portrait of his old acquaintance Gaston Modot.

The paintings done in the Midi should have sold well. They did not, and it seems that there was a virtual conspiracy to hold off until Modigliani was dead. Zborowski actually sold a few things in London at an exhibition organized by the Sitwell brothers in July 1919. Through 1917 and 1918 there had been a great growth in Modigliani's facility in painting. If he produced repetitious works and attempted pot-boilers, it is remarkable that there were not far more. The irony of the neglect he suffered grew more and more disgraceful, and bit deep into his will and the self-esteem which was so necessary to him. It is usual to associate Modigliani's very last style with his despair and final collapse at the end of 1919. It shows a disturbance of the classicism described above, but signs of this may have begun before the autumn of 1919, perhaps associated with domestic stress. There are two paintings of the pregnant Jeanne Hébuterne reproduced in this book. Plate 47 is probably of autumn 1918, in Nice, when she was carrying the first child. The painting is unusual in its profile composition, which, together with the pronounced swan neck and elongated *coiffure*, give it a rare formal elegance. Yet its exaggeration or mannerism is uneasy and disturbs its calm classicism. Plate 48 is certainly from her second pregnancy in 1919–20. Modigliani may have been working on it in the month he died, as he had on the easel at the time of his death a painting in similar style. The extreme pose, with its twisting movement counterbalanced by a sharp tilt of the head, is a still more mannered version of his earlier restrained elegance, but the disequilibrium of the giddy background with its clash of colours is new and startling.

Modigliani was a key figure in the creation of the mythology of 'modern art'. He did not make the running, as Picasso did almost always, and others at various times. His contribution was not an intellectual or even a pseudo-intellectual one – he could not have founded a theory or started a school. None of the *peintres maudits* were in this class. Their role was to bypass the academies and the conditioning that made 'fine artists' and give an authentic visual expression of disturbance of the soul, of cultural upheaval. It was necessary for this role that they could handle paint in ways hardly experienced before, and superbly well. Yet Modigliani did have this conditioning, and retained a respect for the traditions which his compatriots, the Futurists, were trying to kill. His special contribution to modern art was to lay this sense of the past, too, at the foot of the great god, the School of Paris. The 'modern spirit' pervaded his work not intellectually but through the air he breathed and the life he led. It is characteristic of 'modern' art that its traditionalism slowly becomes more apparent. The paradox of Modigliani as a traditionalist within modernism was apparent even in his own lifetime. His technical abilities were sound, and though his paintings betray impatience and the constant battering of distractions in his life, he never lost the outlook of a professional and dedicated artist. He was both the victim of modern times and a symbol of the continuity of artistic expression underlying all change.

Outline Biography

1884 Amedeo Clemente Modigliani born on 12 July at Leghorn (Livorno).

1895 First serious illness.

1898 Attack of typhoid. Begins to study with painter Micheli in Leghorn.

1900 Attack of pleurisy leaves him with tubercular lung.

1901 Travelling with his mother in Italy. Writes his youthful philosophy in letters to a friend, the painter Oscar Ghiglia.

1902 Enrols at the Academy of Fine Art in Florence to attend the life school. First evidence of practice of sculpture.

1903 Enrols for the same course at the Academy of Fine Art in Venice.

1906 Arrives in Paris in January.

1907 Meets Dr Paul Alexandre in the autumn, who acquires about twenty-five paintings and many drawings, the last probably in 1913.

1909 Becomes a neighbour of Brancusi, who reinforces his concentration on sculpture. Visit to his family in Leghorn.

1910 Exhibits paintings at the Salon des Indépendants (as also in 1908).

1911 Photographs taken which later prove the existence of sculptures, some still extant today.

1912 Probably in this year returns to Leghorn, obtains stone, and carves, perhaps abandoning the work in Leghorn. But in the autumn, shows seven sculptured heads at the Salon d'Automne.

1914 Meets Beatrice Hastings. Begins to concentrate on painting.

1915 First year with a substantial number of paintings. Paul Guillaume buys and sells some.

1916 Meets Leopold Zborowski who becomes his dealer and supports him with regular payments.

1917 Meets Jeanne Hébuterne, sets up with her in lodgings rented for them by Zborowski. An exhibition at the Berthe Weill Gallery in December closes on the first day by order of the police, who consider the nudes obscene.

1918 Modigliani and Jeanne, Zborowski and his wife, and Jeanne's mother go to Nice. Many paintings this year and in 1919.

1919 Modigliani returns alone to Paris in May. Jeanne and child return end of June. Child put out to nurse. Modigliani is included in an exhibition in London in July.

1920 Death of Modigliani on 24 January.
Suicide of Jeanne Hébuterne on 25 January.

Select Bibliography

Ambrogio Ceroni: *Amedeo Modigliani, peintre* (incorporating the memoirs of Lunia Czechowska). Edizioni del Milione, Milan, 1958. Text in French (Ceroni I).

Ambrogio Ceroni: *Amedeo Modigliani, dessins et sculptures* (with an appendix of 65 paintings not reproduced in the previous volume). Edizioni del Milione, Milan, 1965. Text in French (Ceroni II).

Jean Lanthemann: *Modigliani, catalogue raisonné*. Contributions by Nello Ponente and Jeanne Modigliani. Privately printed in Barcelona, 1970.

L. Piccioni and A. Ceroni: *I Dipinti di Modigliani* (*Classici dell'Arte* series). Rizzoli Editore, Milan, 1970.

Alfred Werner: *Modigliani the Sculptor*. Thames & Hudson, London, 1965.

Jeanne Modigliani (Nechtstein): *Modigliani: Man and Myth*. André Deutsch, London, 1959. Translated from the Italian, *Modigliani senza leggenda*. The French version, *Modigliani sans légende*, 1961, has a few extra passages.

Pierre Sichel: *Modigliani*. W. H. Allen, London, 1967. The most comprehensive biography, drawing on a very large number of written and verbal sources.

Charles Douglas (pseud. for Douglas Goldring): *Artist Quarter*. Faber, London, 1941.

John Russell: *Modigliani* (catalogue of exhibition, Edinburgh and London, 1963).

Franco Russoli: *Modigliani*. Thames & Hudson, London, 1959.

Nello Ponente: *Modigliani*. Thames & Hudson, London, 1969.

Jacques Lipchitz: *Amedeo Modigliani*. Express Art Books, London, 1968.

Benedict Nicolson: *Modigliani paintings*. Editions du Chêne, Paris, and Lindsay Drummond, London, 1948.

William Fifield: *Modigliani, the biography*, W. H. Allen, London, 1978.

List of Plates

1. *Portrait of Pedro.* 1909. Oil on canvas, 55 × 46 cm. Private Collection.
2. *Standing Nude.* About 1911. Oil on paper, 83 × 48 cm. New York, Perls Galleries.
3. *Head.* About 1911. Stone. New York, Perls Galleries.
4. *Head.* About 1912. Stone, height 45 cm. New York, Perls Galleries.
5. *Portrait of a Woman.* 1915. Oil. New York, Perls Galleries.
6. *Head of a Woman wearing a Hat.* 1907. Watercolour, 35 × 27 cm. Boston, Massachusetts, William Young & Company.
7. *The Amazon.* 1909. Oil on canvas, 92 × 65 cm. Collection of Mr and Mrs Alexander Lewyt.
8. *Caryatid.* About 1913. Watercolour, 83 × 43 cm. London, Marlborough Fine Art.
9. *Caryatid.* About 1913. Crayon. New York, Perls Galleries.
10. *Caryatid.* About 1912–13. Stone, height 92 cm. New York, Museum of Modern Art (Mrs Simon Guggenheim Fund).
11. *Caryatid (Audace).* About 1913. Gouache, 60 × 45 cm. West Palm Beach, Florida, Norton Gallery and School of Art.
12. *Head.* About 1911. Stone, height 64 cm. New York, Solomon R. Guggenheim Museum.
13. *Head.* About 1911. Stone, height 58 cm. Paris, Musées Nationaux.
14. *Head.* About 1911. Stone, height 88 cm. London, Tate Gallery.
15. *Pierrot.* 1915. Oil on cardboard, 43 × 27 cm. Copenhagen, Statens Museum for Kunst (J. Rump Collection).
16. *Diego Rivera.* 1914. Oil on canvas, 100 × 81 cm. Private Collection.
17. *Study for Portrait of Frank Haviland.* 1914. Oil on cardboard, 61 × 50 cm. Los Angeles County Museum of Art.
18. *Beatrice Hastings.* 1915. Oil on canvas, 55 × 46 cm. Toronto, Art Gallery of Ontario (Gift of Sam and Ayala Zacks).
19. *Antonia.* 1915. Oil on canvas, 82 × 46 cm. Paris, Musées Nationaux.
20. *Celso Lagar.* 1915. Oil on canvas, 35 × 27 cm. Private Collection.
21. *The Couple.* 1915. Oil on canvas, 55 × 46 cm. New York, Museum of Modern Art (Gift of Frederic Clay Bartlett).
22. *Jean Cocteau.* 1916. Oil on canvas, 100 × 81 cm. New York, Henry and Rose Pearlman Foundation Inc.
23. *Paul Guillaume, seated.* 1916. Oil on canvas, 81 × 54 cm. Milan, Galleria d'Arte Moderna.
24. *Juan Gris.* 1915. Oil on canvas, 55.5 × 38 cm. New York, Metropolitan Museum of Art.
25. *Chaim Soutine seated at a table.* 1916–17. Oil on canvas, 92 × 60 cm. Washington, National Gallery of Art (Chester Dale Collection).
26. *Seated Nude.* 1916. Oil on canvas, 92 × 60 cm. London, Courtauld Institute Galleries.
27. *Seated Nude.* 1917. Oil on canvas, 81 × 65 cm. Private Collection.
28. *Monsieur Lepoutre.* 1916. Oil on canvas, 92 × 65 cm. Private Collection.
29. *The Sculptor Lipchitz and his Wife.* 1916. Oil on canvas, 81 × 54 cm. Chicago, Art Institute.
30. *Portrait of a Girl (Victoria).* 1917. Oil on canvas, 81 × 60 cm. London, Tate Gallery.
31. *Madame Zborowska on a Sofa.* 1917. Oil on canvas, 130 × 81 cm. New York, Museum of Modern Art (Lillie P. Bliss Collection).
32. *Reclining Nude with Blue Cushion.* 1917. Oil on canvas, 60 × 92 cm. New York, Collection of Mr Nathan Cummings.
33. *Reclining Nude, raised on her right arm.* 1917. Oil on canvas, 65 × 100 cm. Washington, National Gallery of Art (Chester Dale Collection).
34. *Portrait of a Girl.* 1917–18. Oil on canvas, 46 × 29 cm. Private Collection.
35. *Leopold Zborowski.* 1918. Oil on canvas, 46 × 27 cm. Private Collection.
36. *Reclining Nude.* 1917. Oil on canvas, 60 × 92 cm. Stuttgart, Staatsgalerie.
37. *Nude, looking over her right shoulder.* 1917. Oil on canvas, 89 × 146 cm. Private collection.
38. *Reclining Nude (called Le Grand Nu).* 1917. Oil on canvas, 73 × 116 cm. New York, Museum of Modern Art (Mrs Simon Guggenheim Fund).
39. *Nude with necklace, her eyes closed.* 1917. Oil on canvas, 73 × 116 cm. New York, Solomon R. Guggenheim Museum.
40. *The Young Apprentice.* 1918. Oil on canvas, 100 × 65 cm. New York, Solomon R. Guggenheim Museum.
41. *The Little Peasant.* 1918. Oil on canvas, 100 × 65 cm. London, Tate Gallery.
42. *La Belle Epicière.* 1918. Oil on canvas, 100 × 65 cm. Private Collection.
43. *Little Girl in Blue.* 1918. Oil on canvas, 116 × 73 cm. Private Collection.
44. *Seated Boy with Cap.* 1918. Oil on canvas, 100 × 65 cm. Private Collection.
45. *Girl in a White Chemise.* 1918. Oil on canvas, 73 × 50 cm. Private Collection.
46. *Jeanne Hébuterne.* 1918. Oil on canvas, 92 × 60 cm. Private Collection.
47. *Jeanne Hébuterne in Profile.* 1918. Oil on canvas, 100 × 65 cm. Private Collection.
48. *Jeanne Hébuterne, a door in the background.* 1919–20. Oil on canvas, 130 × 81 cm. New York, Sotheby Parke Bernet Inc.

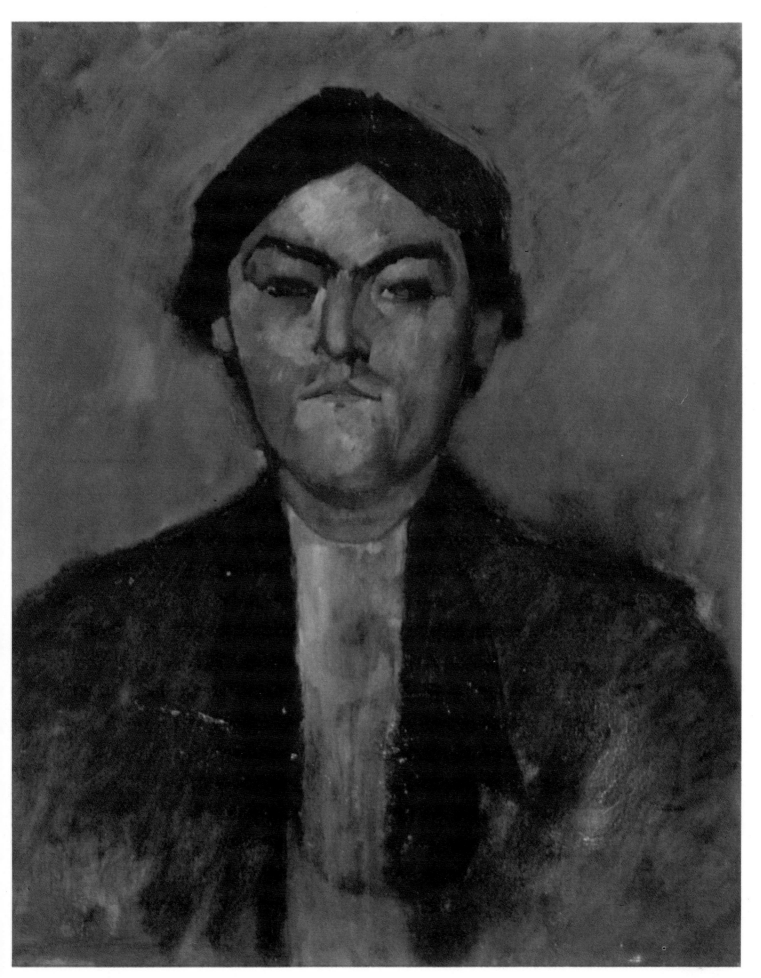

1. *Portrait of Pedro.* 1909.
Private Collection

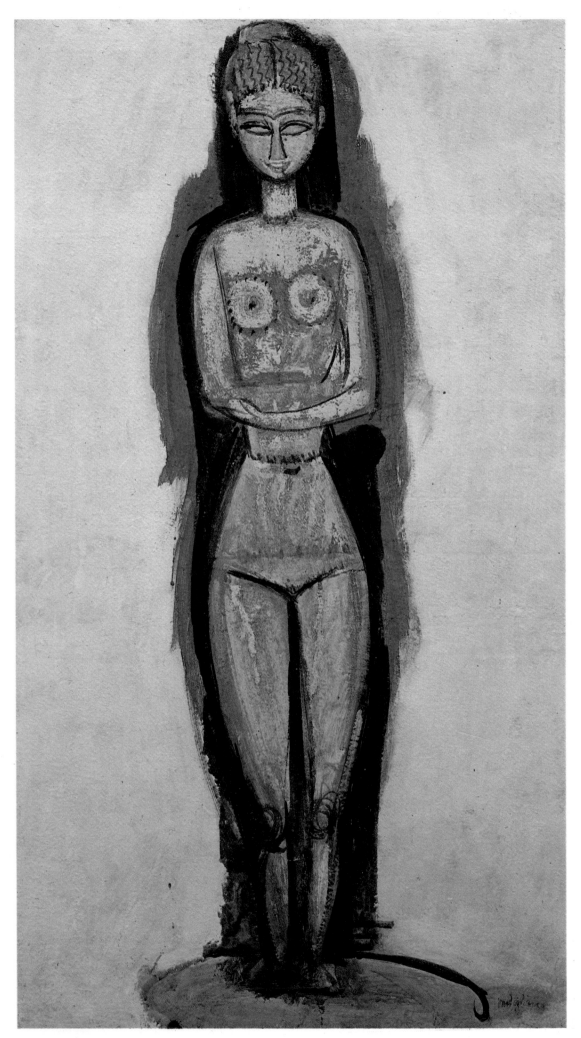

2. *Standing Nude*. About 1911.
New York, Perls Galleries

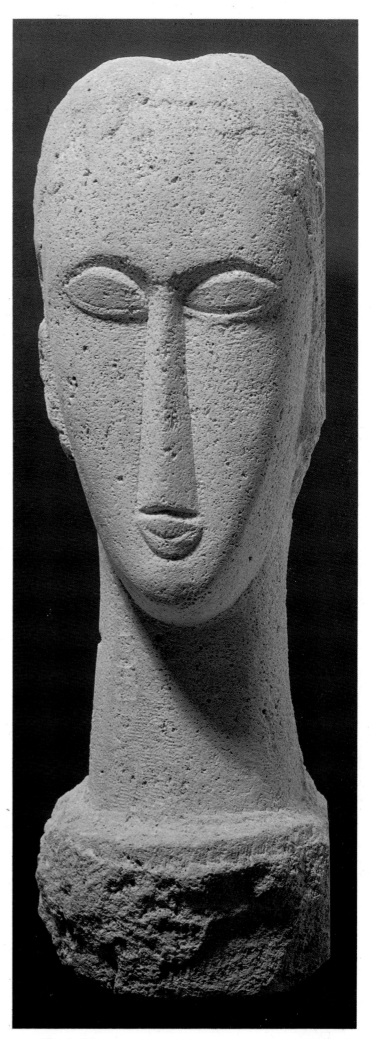

3. *Head*. About 1911.
New York, Perls Galleries

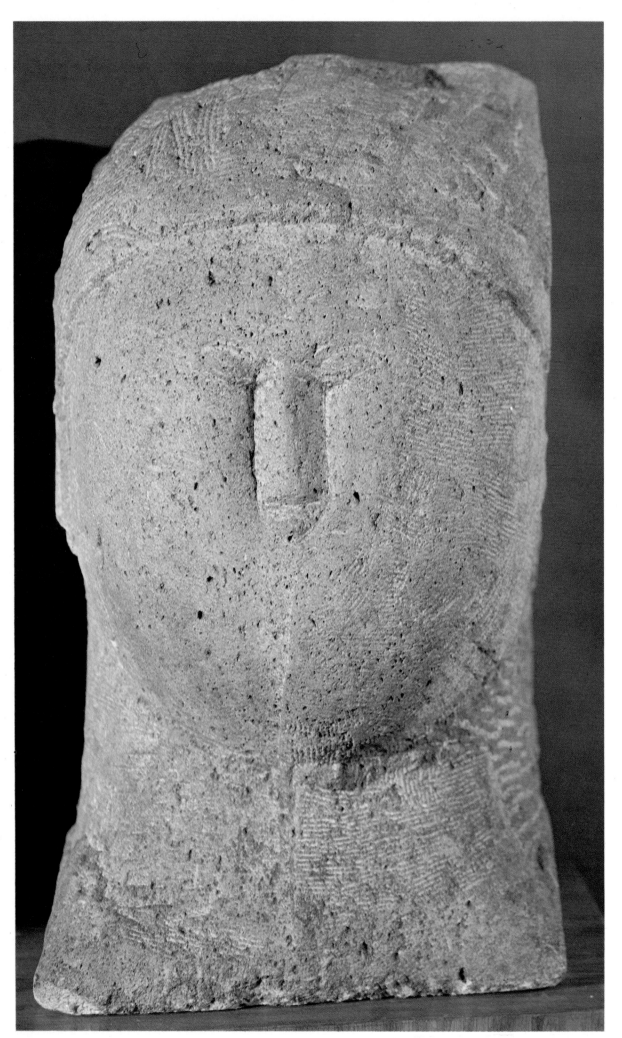

4. *Head.* About 1912.
New York, Perls Galleries

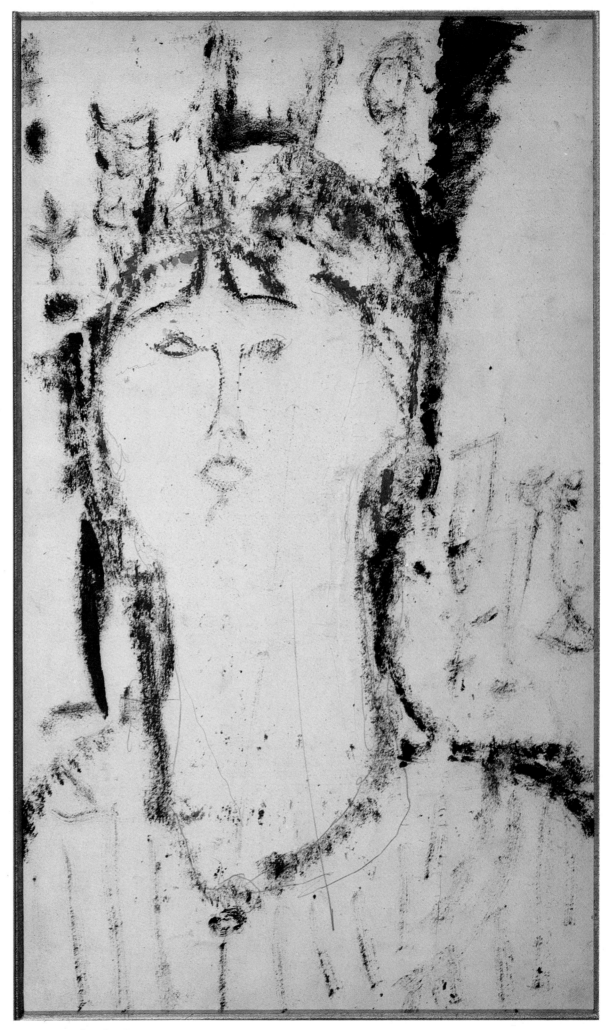

5. *Portrait of a Woman.* 1915.
 New York, Perls Galleries

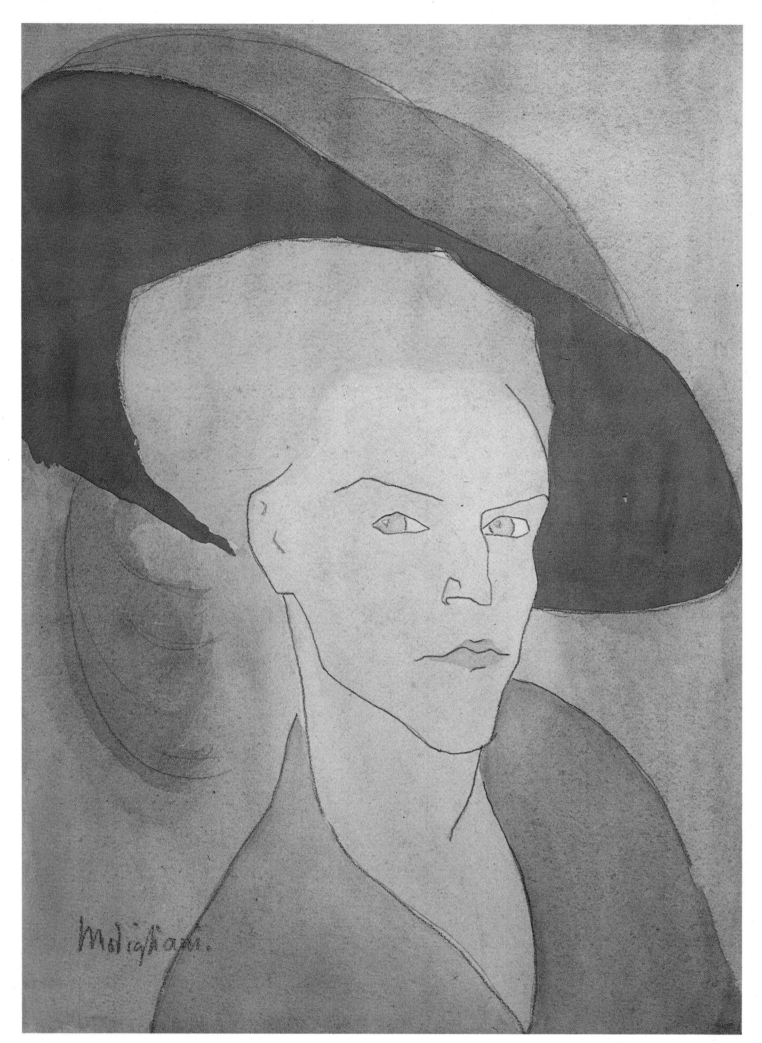

6. *Head of a Woman wearing a Hat.* 1907.
Boston, Massachusetts, William Young & Company

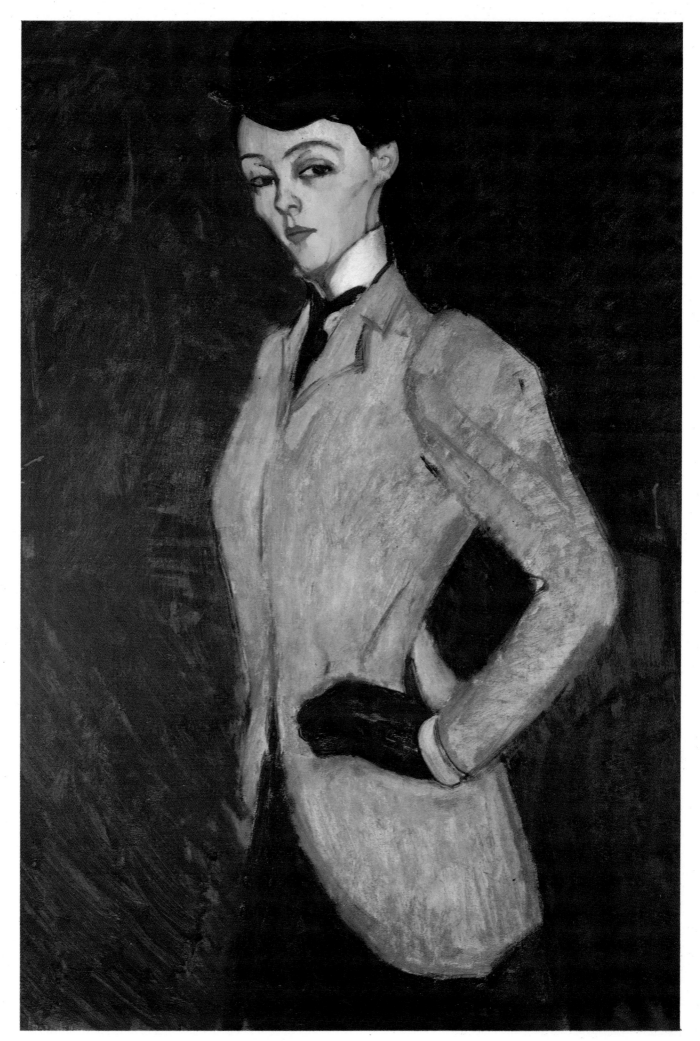

7. *The Amazon.* 1909.
 Collection of Mr and Mrs Alexander Lewyt

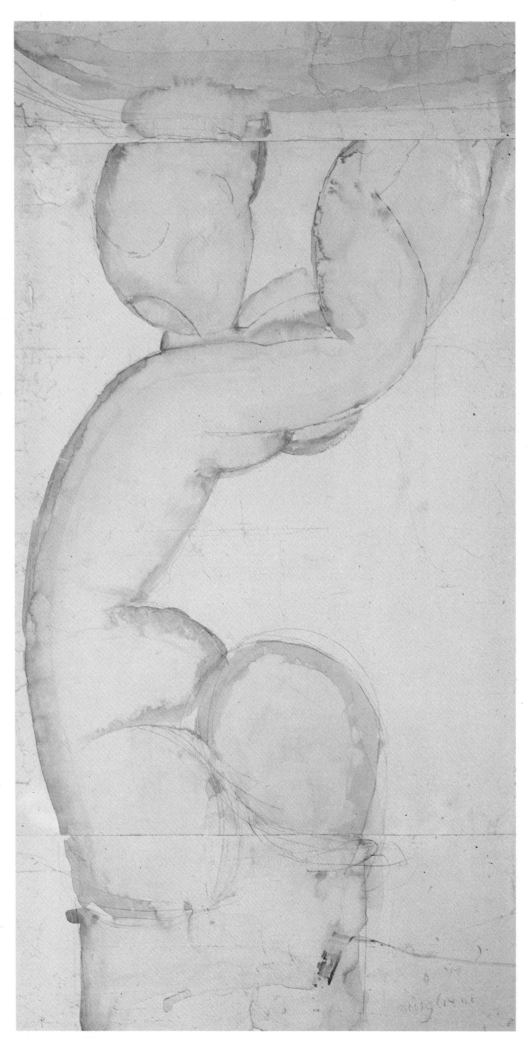

8. *Caryatid*. About 1913.
London, Marlborough Fine Art

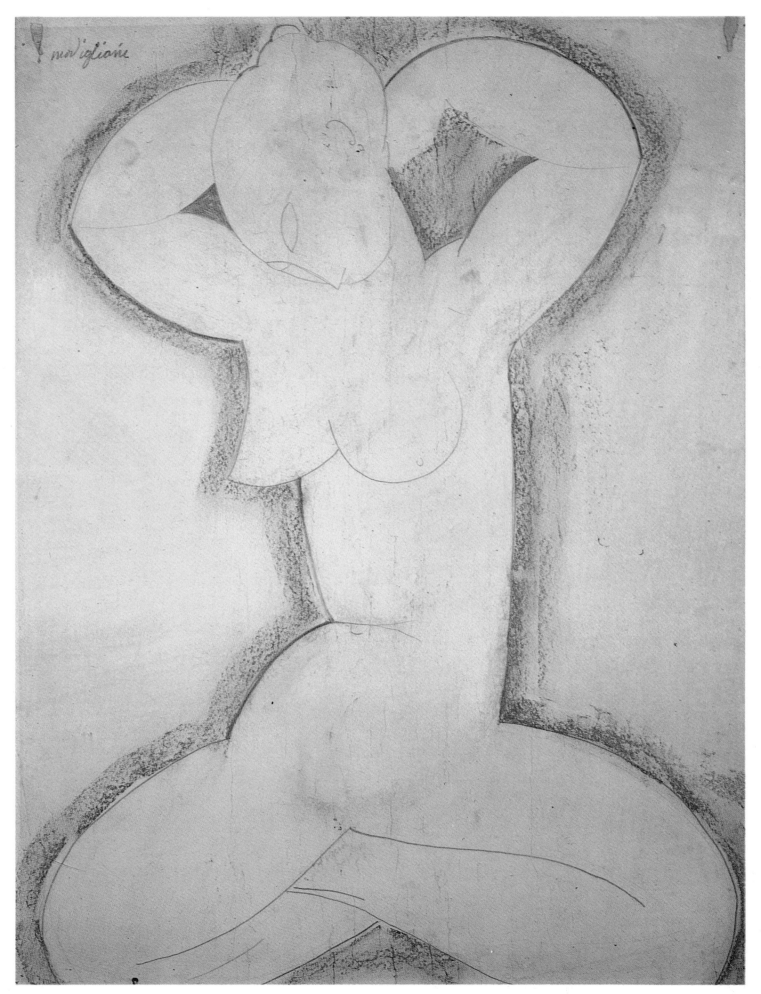

9. *Caryatid*. About 1913.
New York, Perls Galleries

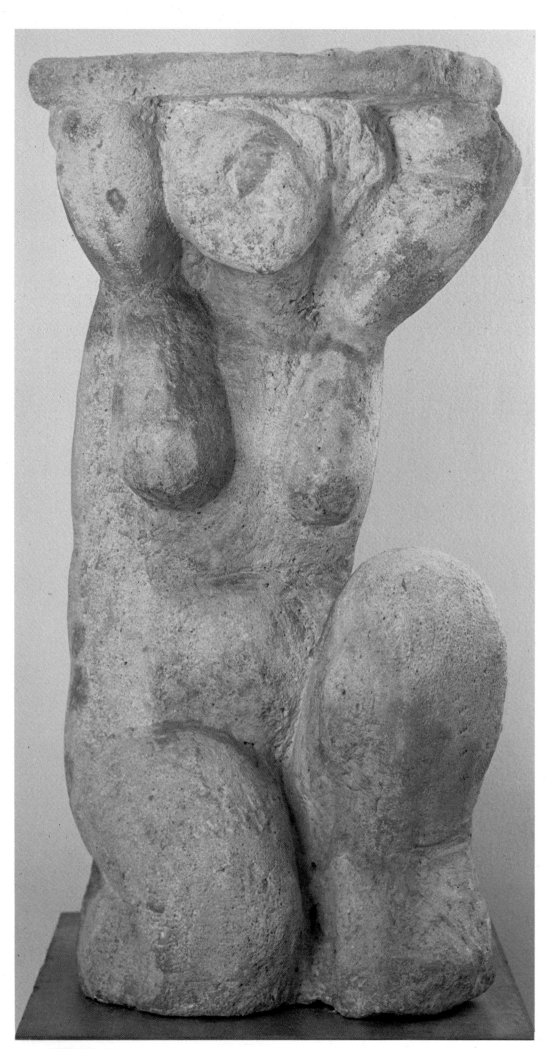

10. *Caryatid*. About 1912–13.
New York, Museum of Modern Art (Mrs Simon Guggenheim Fund)

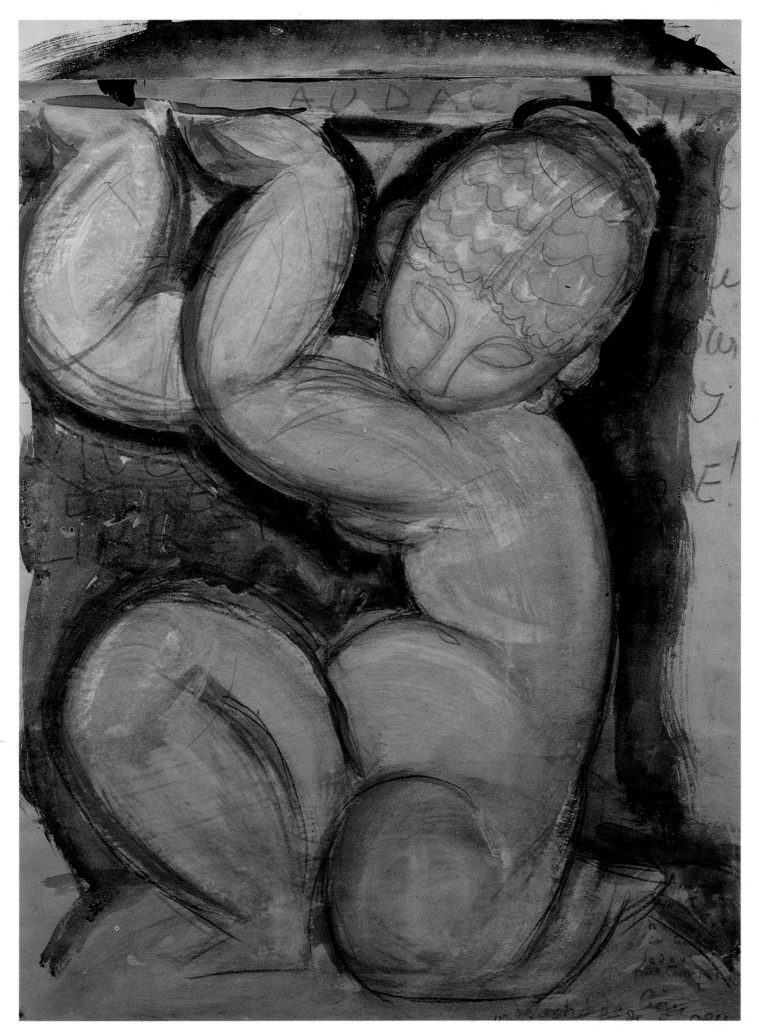

11. *Caryatid* (*Audace*). About 1913.
West Palm Beach, Florida, Norton Gallery and School of Art

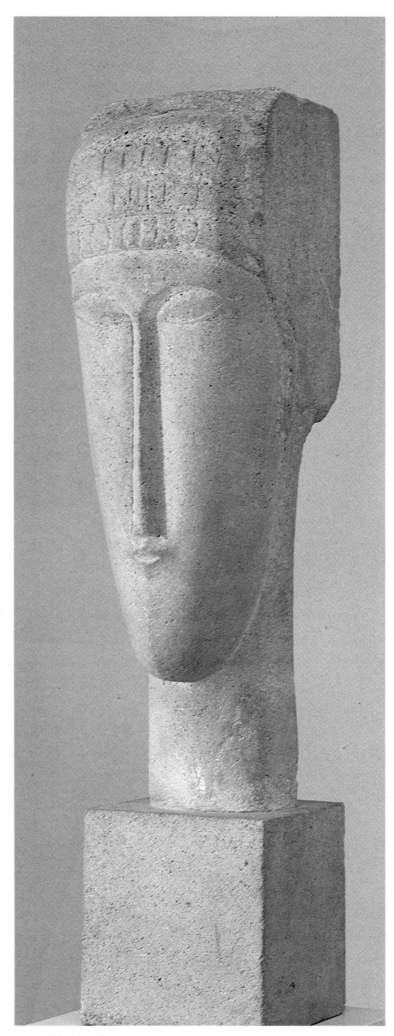

12. *Head*. About 1911.
New York, Solomon R. Guggenheim Museum

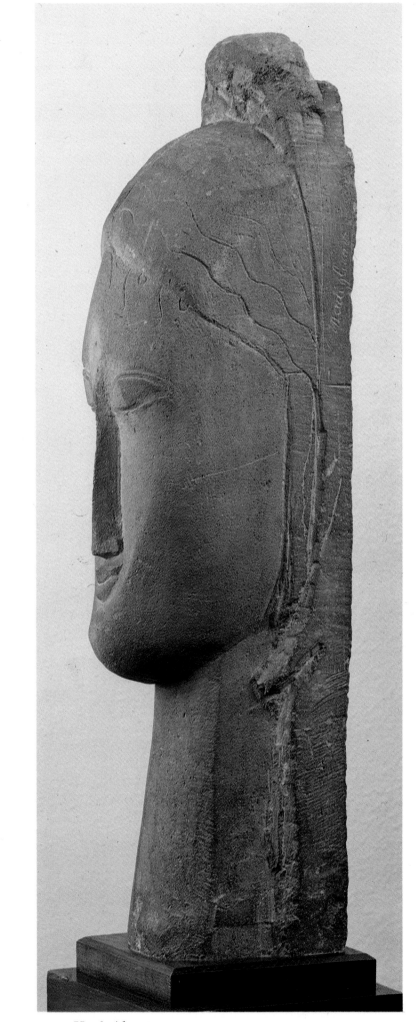

13. *Head*. About 1911.
Paris, Musées Nationaux

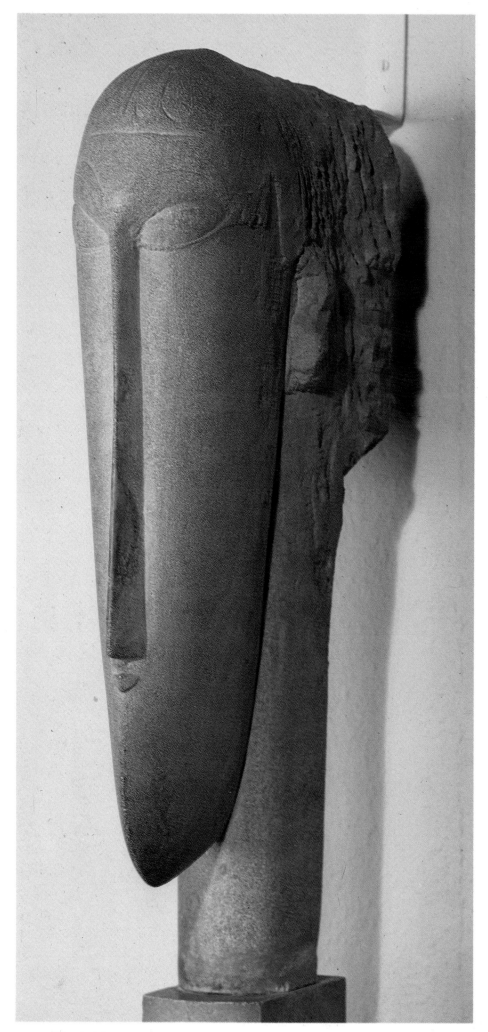

14. *Head*. About 1911.
London, Tate Gallery

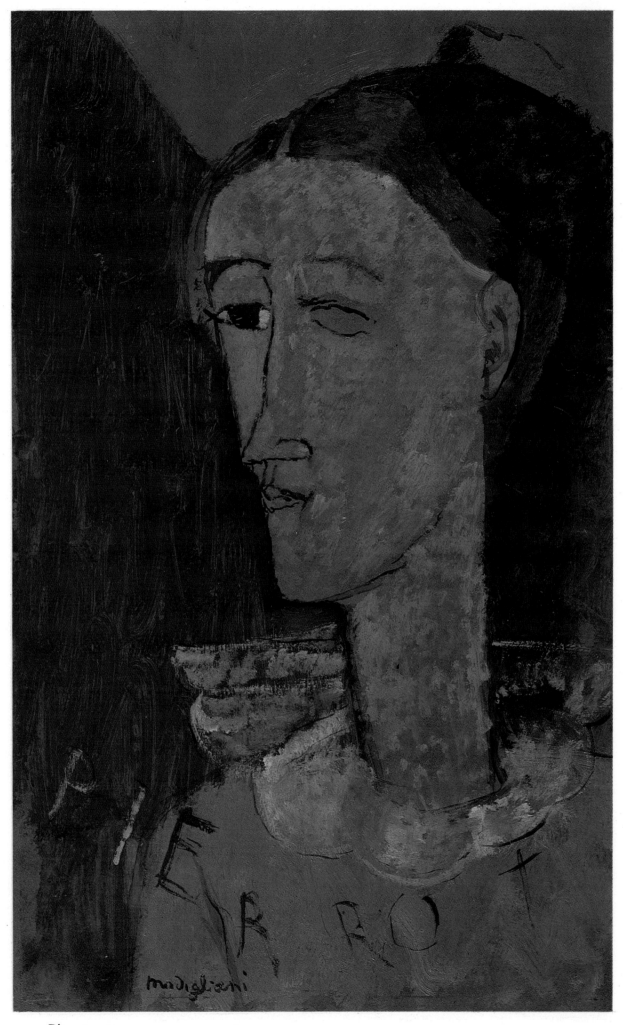

15. *Pierrot.* 1915.
Copenhagen, Statens Museum for Kunst (J. Rump Collection)

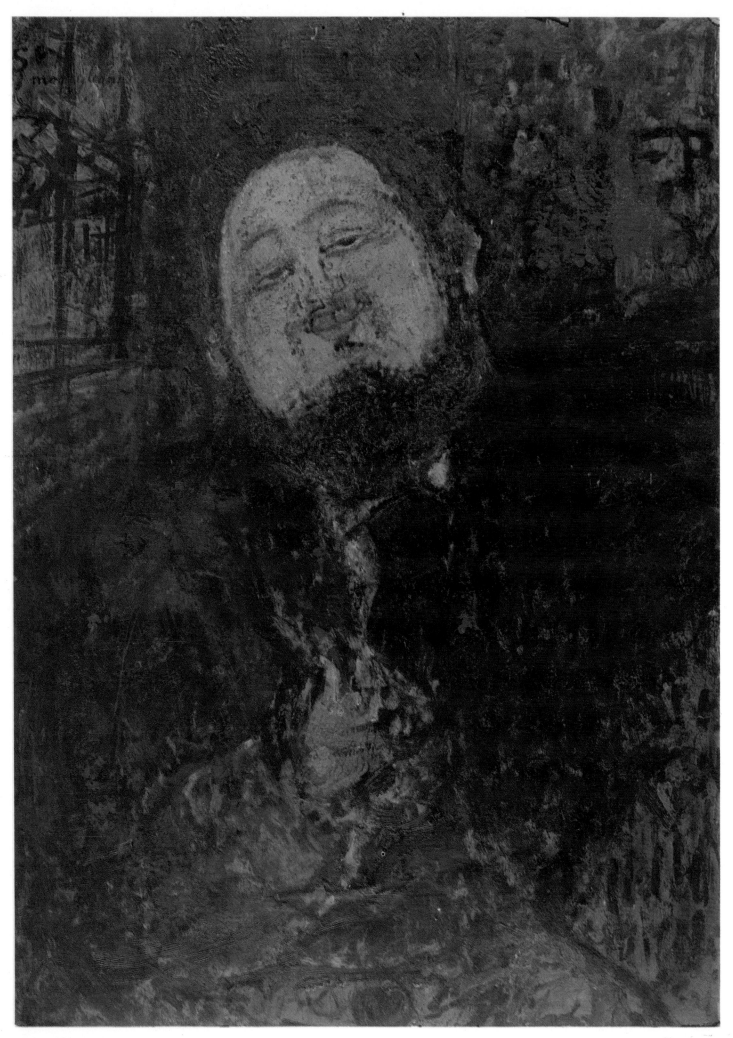

16. *Diego Rivera.* 1914.
Private Collection

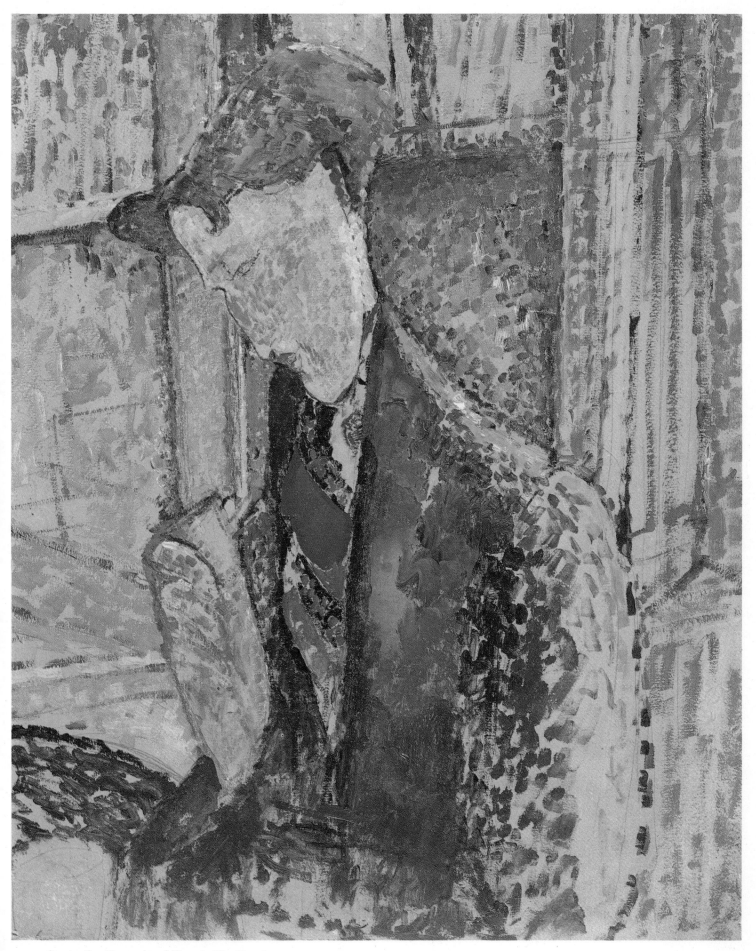

17. *Study for Portrait of Frank Haviland.* 1914.
Los Angeles County Museum of Art

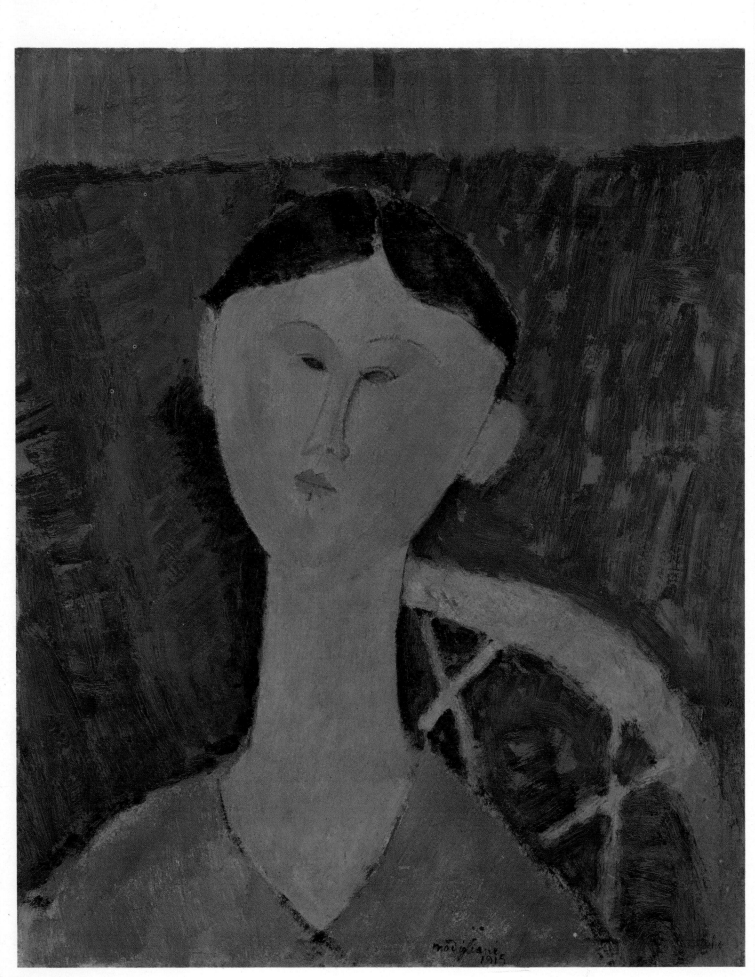

18. *Beatrice Hastings.* 1915.
 Toronto, Art Gallery of Ontario (Gift of Sam and Ayala Zacks)

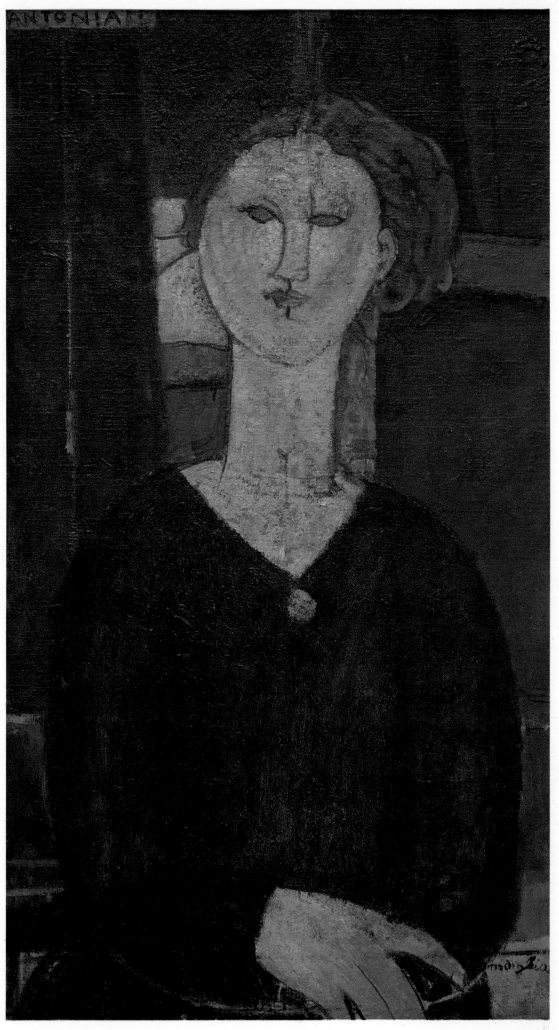

19. *Antonia*. 1915.
Paris, Musées Nationaux

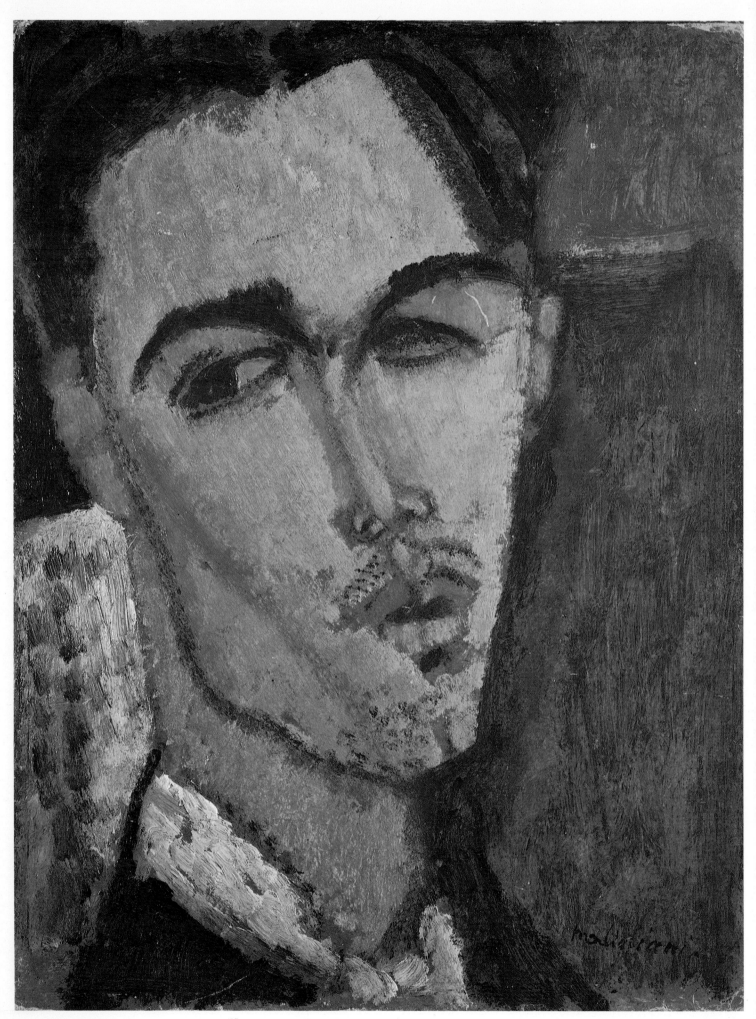

20. *Celso Lagar.* 1915.
Private Collection

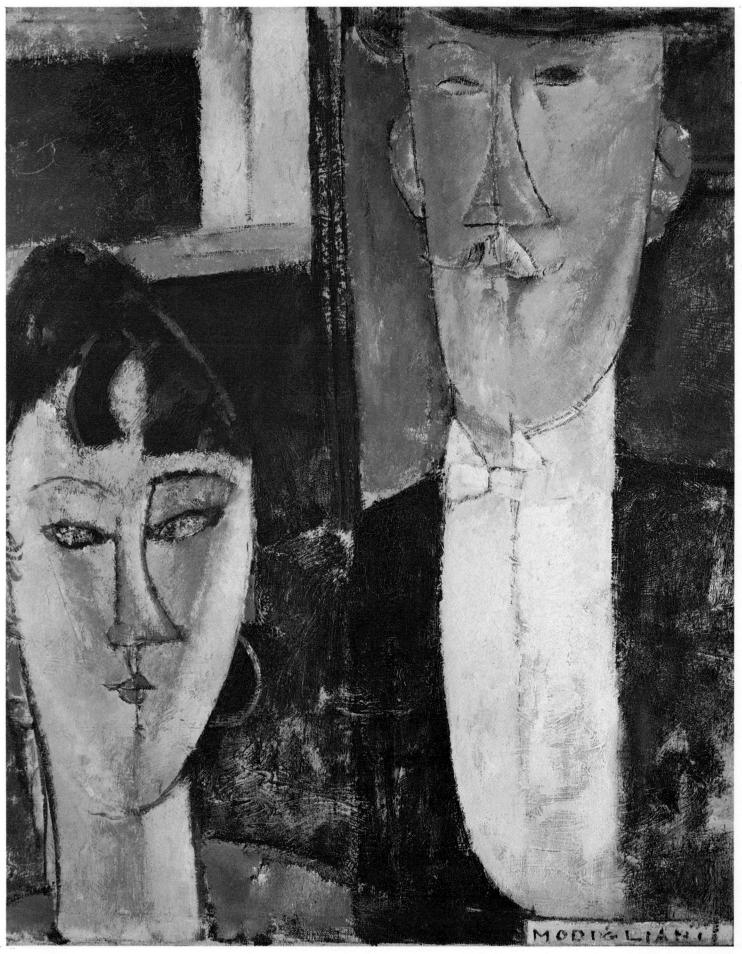

21. *The Couple*. 1915.
New York, Museum of Modern Art (Gift of Frederic Clay Bartlett)

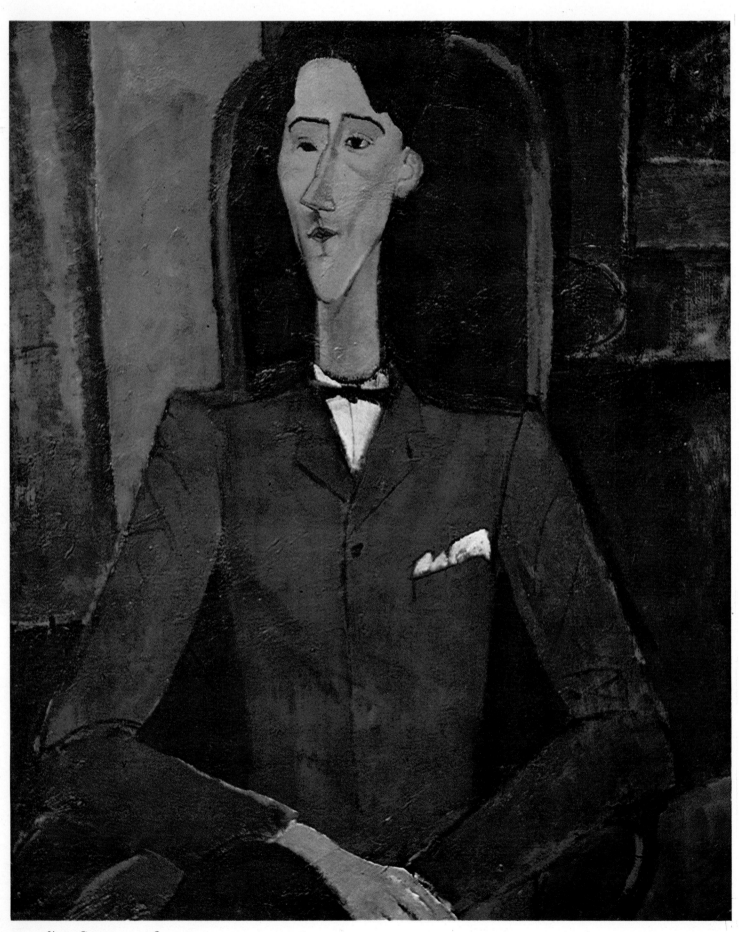

22. *Jean Cocteau*. 1916.
New York, Henry and Rose Pearlman Foundation Inc.

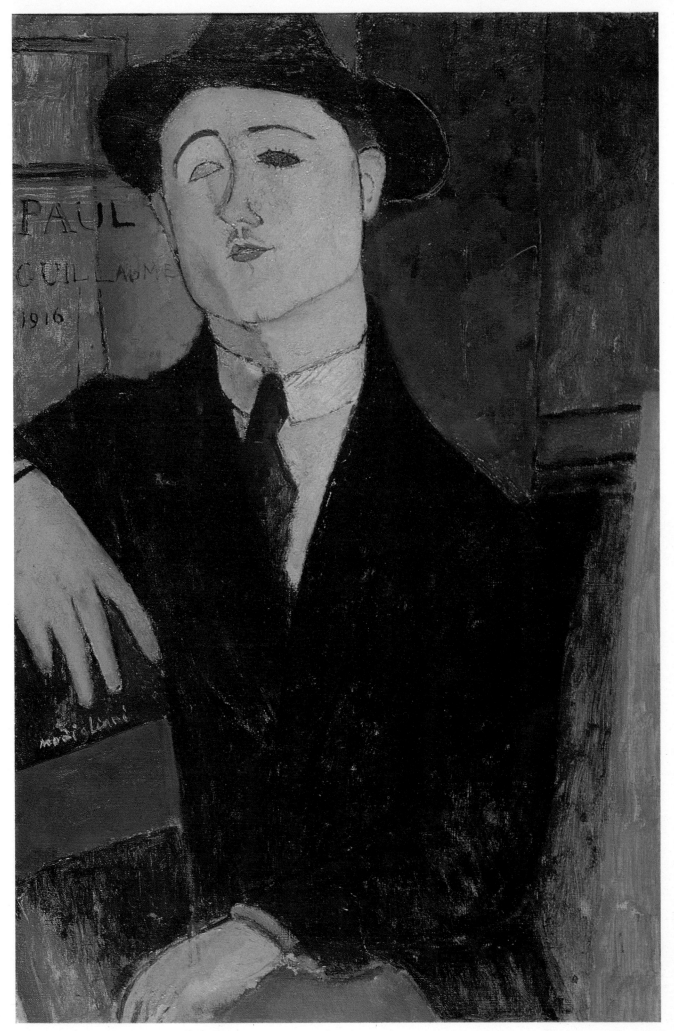

23. *Paul Guillaume, seated.* 1916.
Milan, Galleria d'Arte Moderna

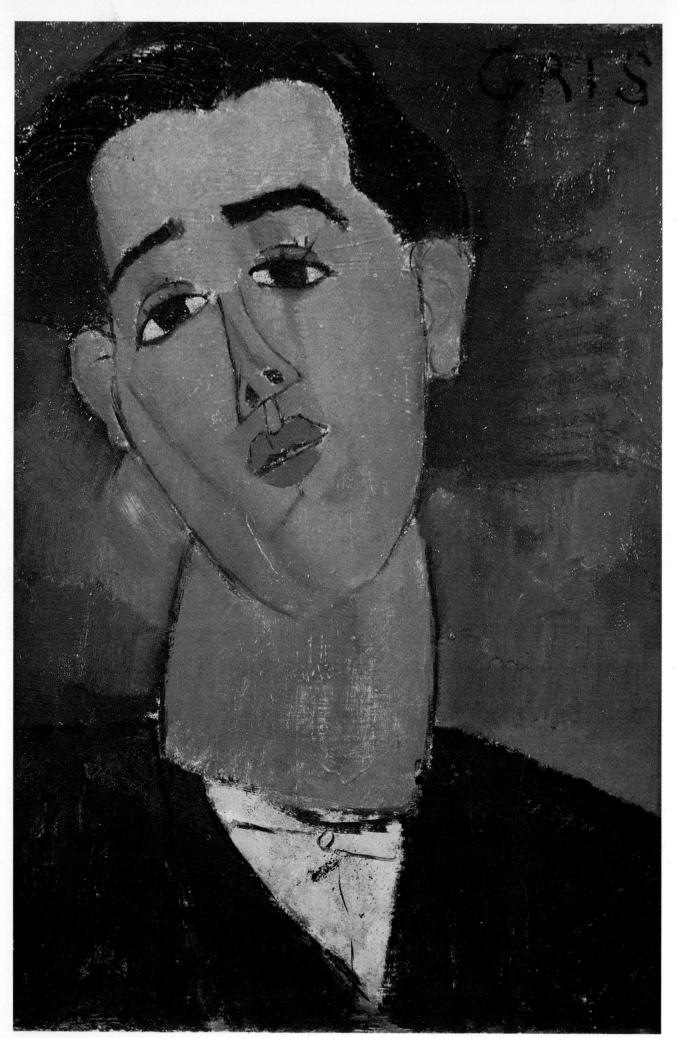

24. *Juan Gris.* 1915.
New York, Metropolitan Museum of Art

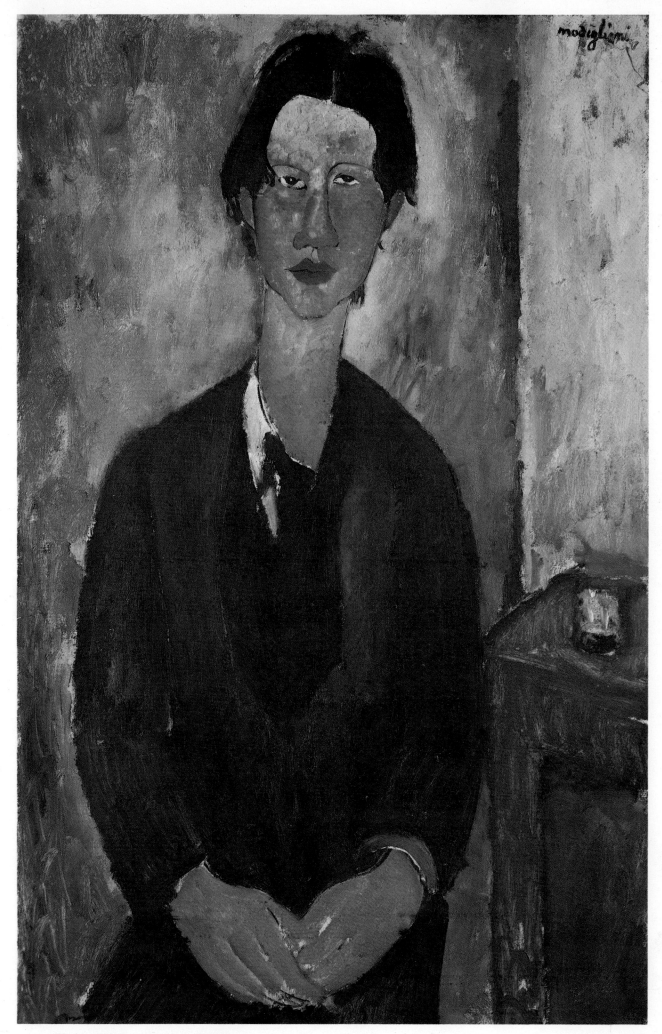

25. *Chaim Soutine seated at a table.* 1916–17.
Washington, National Gallery of Art (Chester Dale Collection)

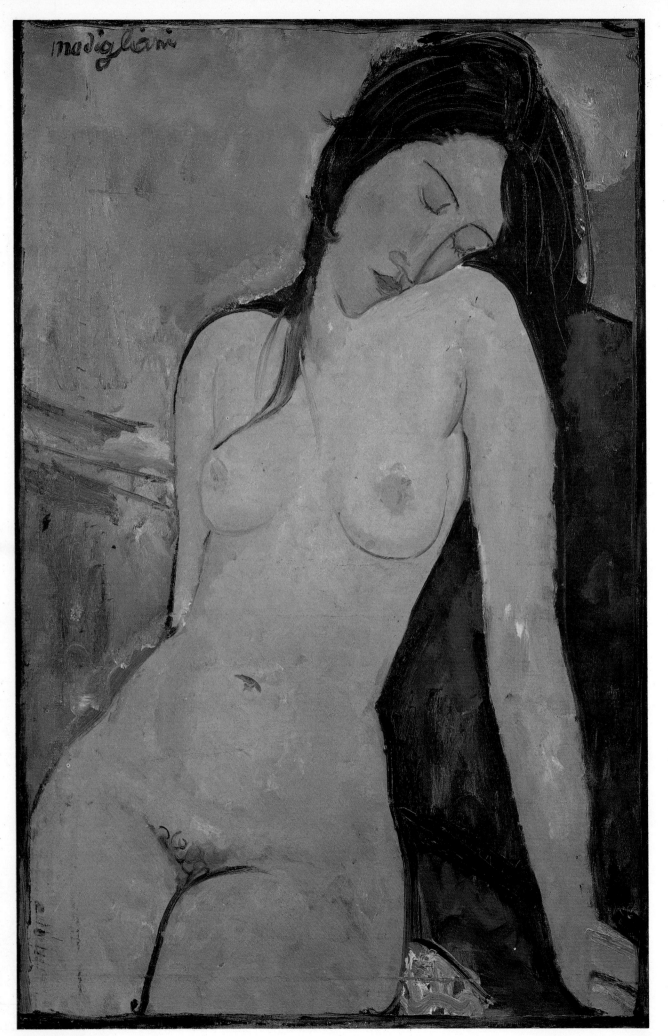

26. *Seated Nude.* 1916.
London, Courtauld Institute Galleries

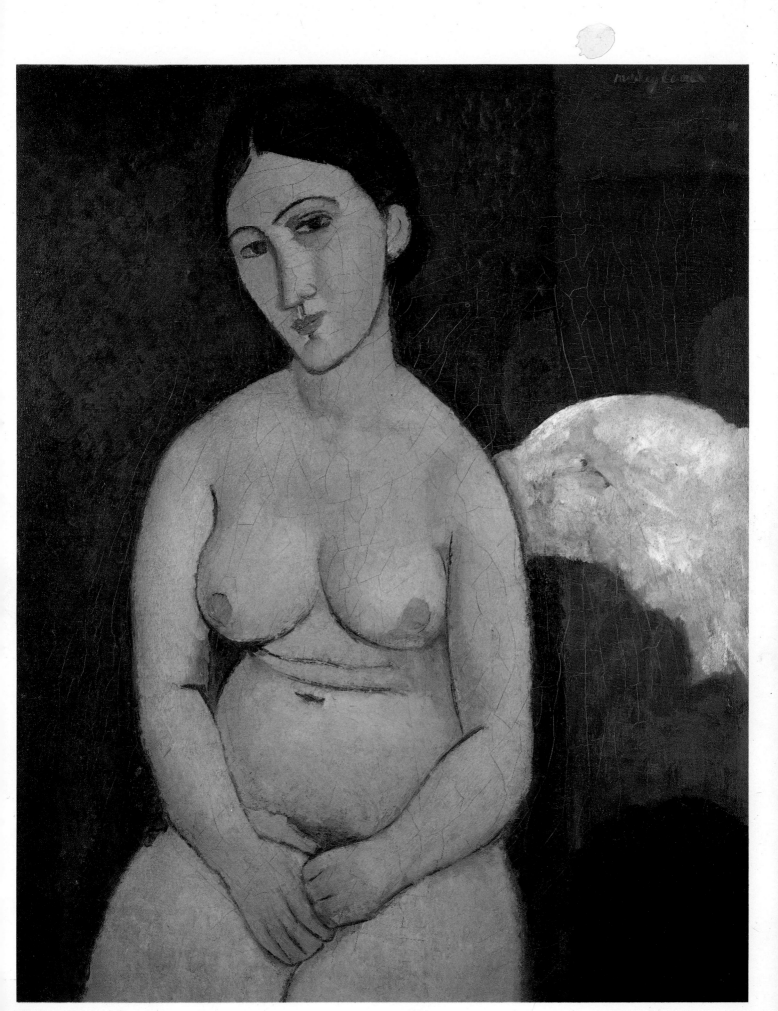

27. *Seated Nude.* 1917.
Private Collection

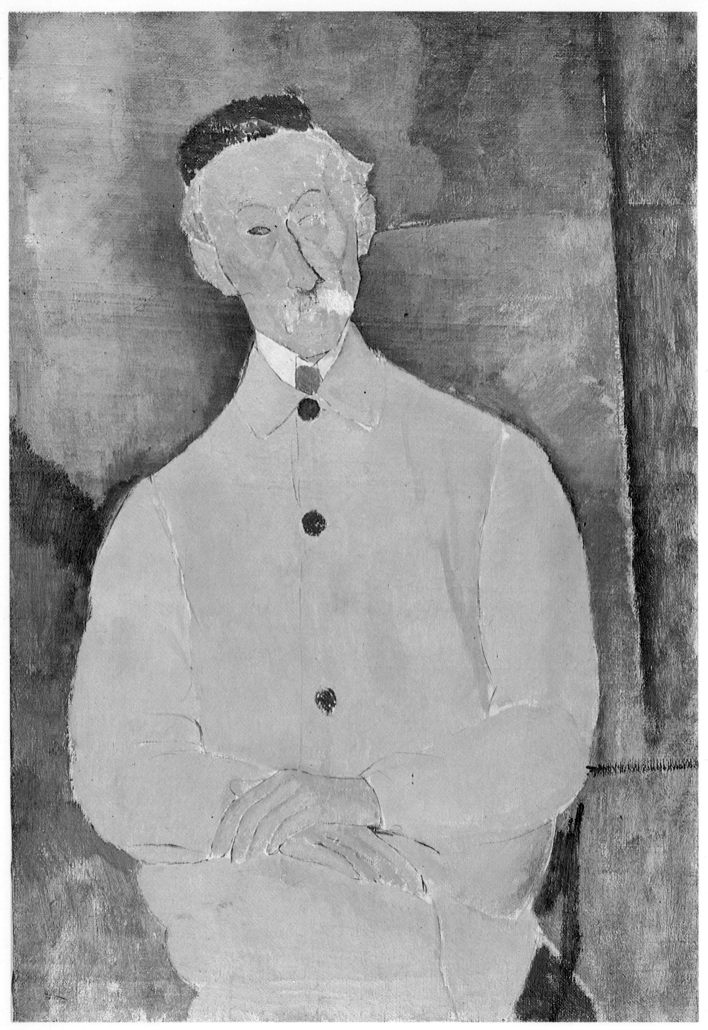

28. *Monsieur Lepoutre.* 1916.
Private Collection

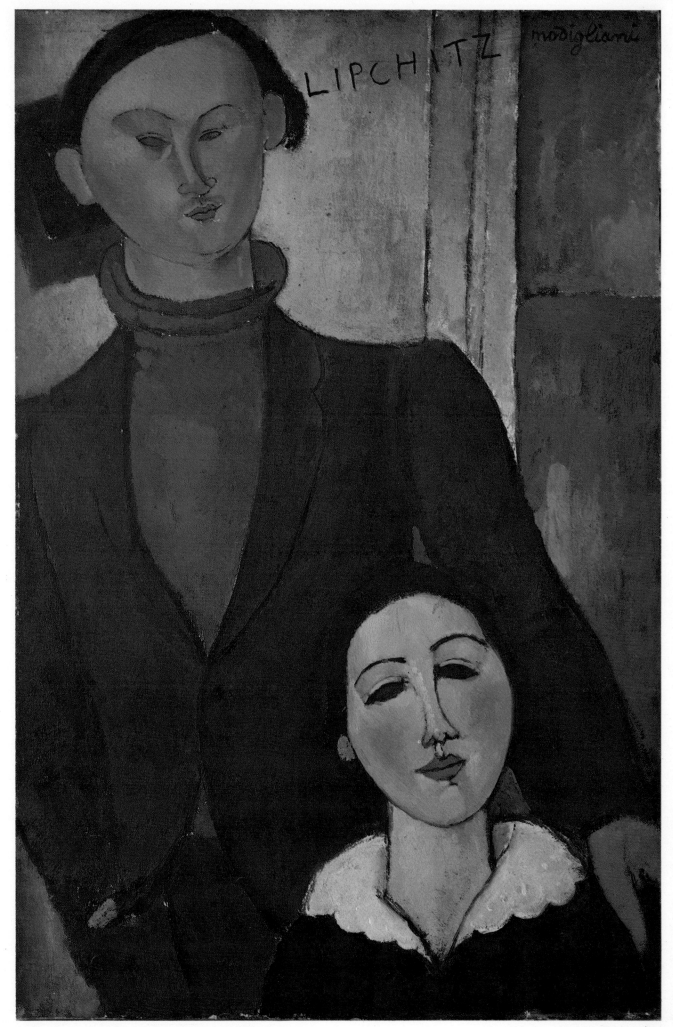

29. *The Sculptor Lipchitz and his Wife*. 1916.
Chicago, Art Institute

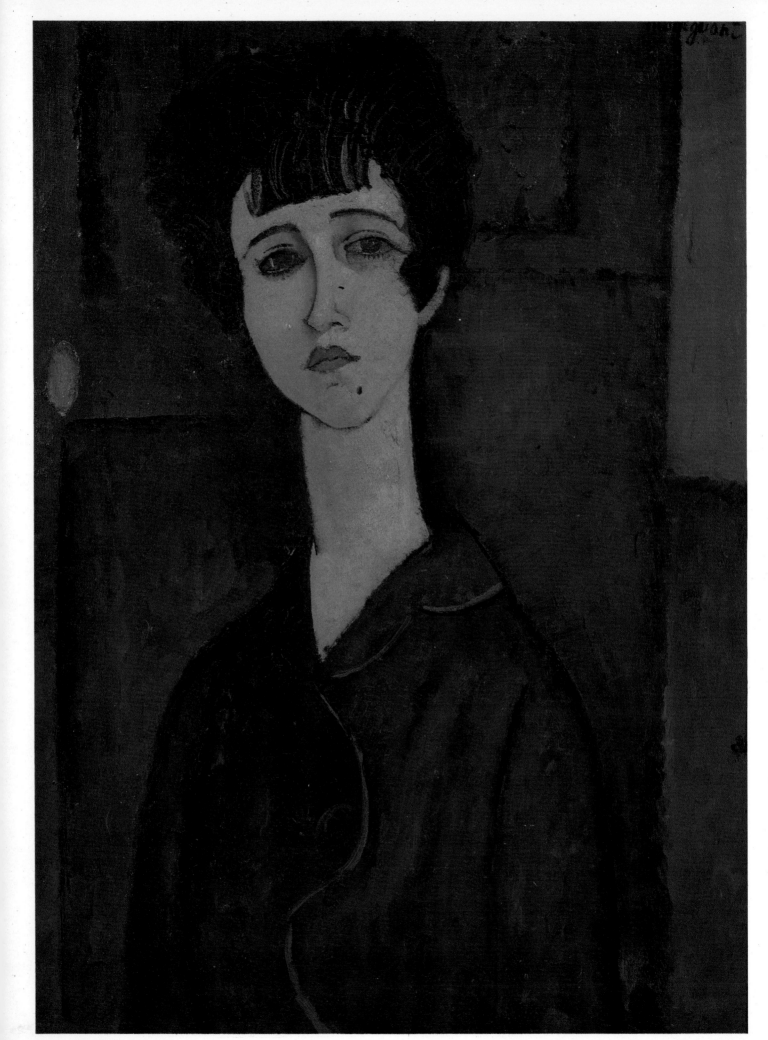

30. *Portrait of a Girl (Victoria).* 1917.
London, Tate Gallery

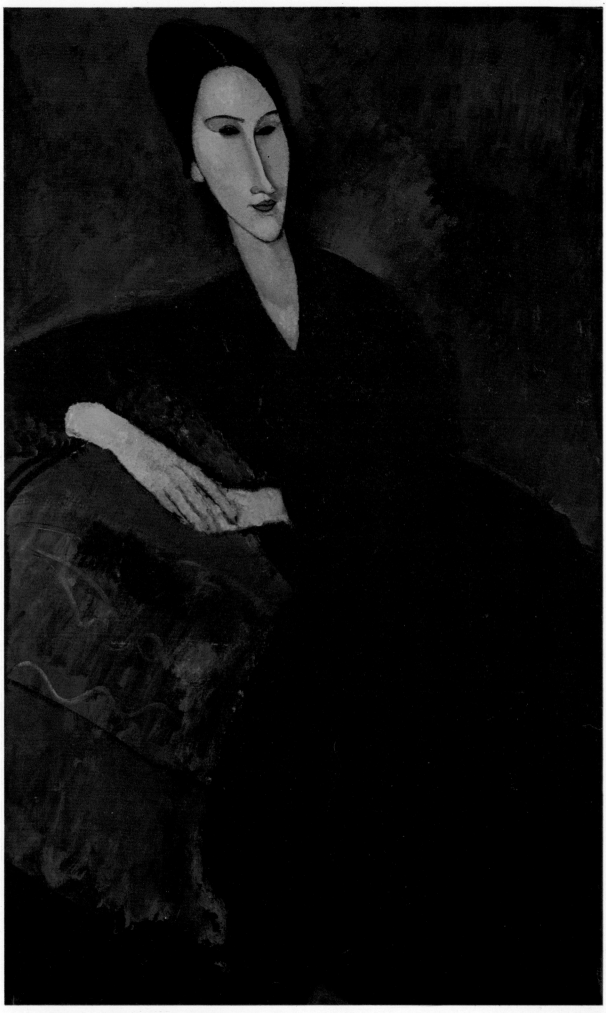

31. *Madame Zborowska on a Sofa.* 1917.
New York, Museum of Modern Art (Lillie P. Bliss Collection)

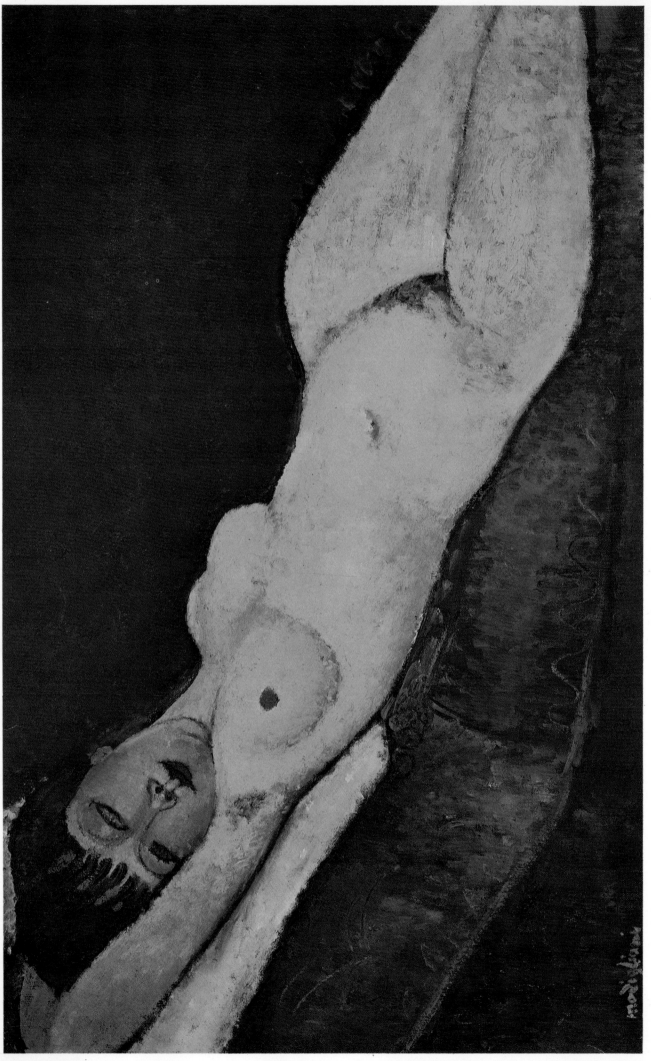

32. *Reclining Nude with Blue Cushion.* 1917.
New York, Collection of Mr Nathan Cummings

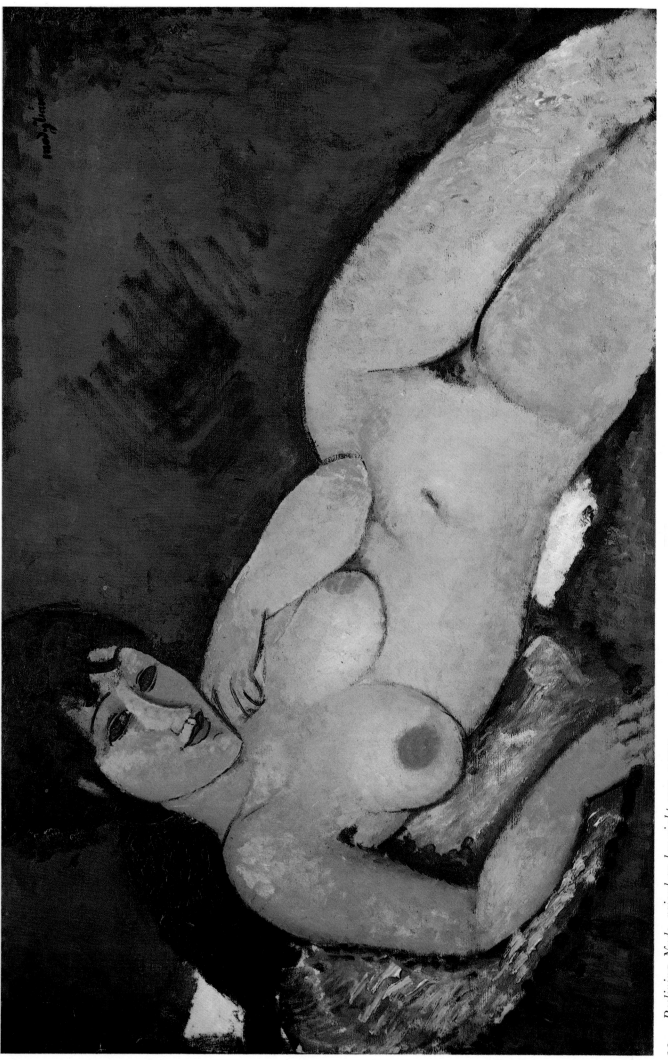

33. *Reclining Nude, raised on her right arm.* 1917.
Washington, National Gallery of Art (Chester Dale Collection)

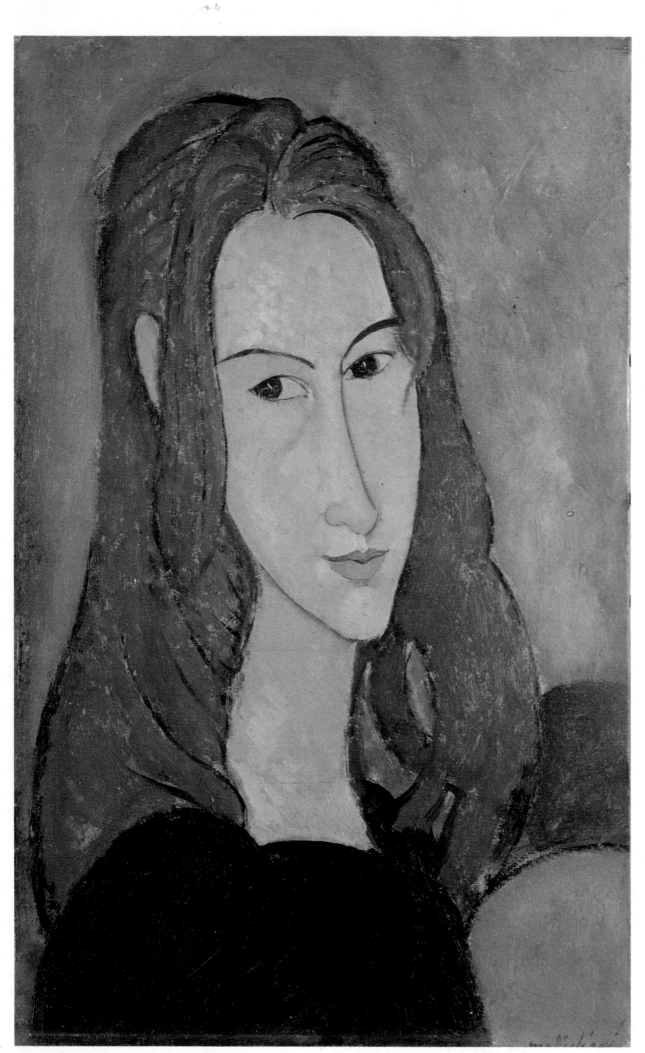

34. *Portrait of a Girl.* 1917–18.
Private Collection

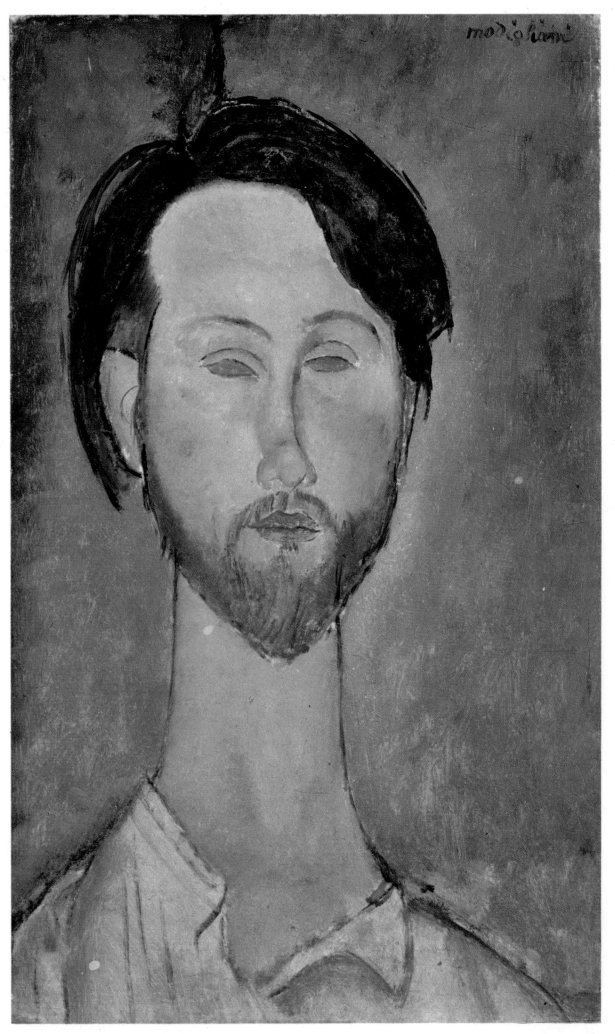

35. *Leopold Zborowski.* 1918.
Private Collection

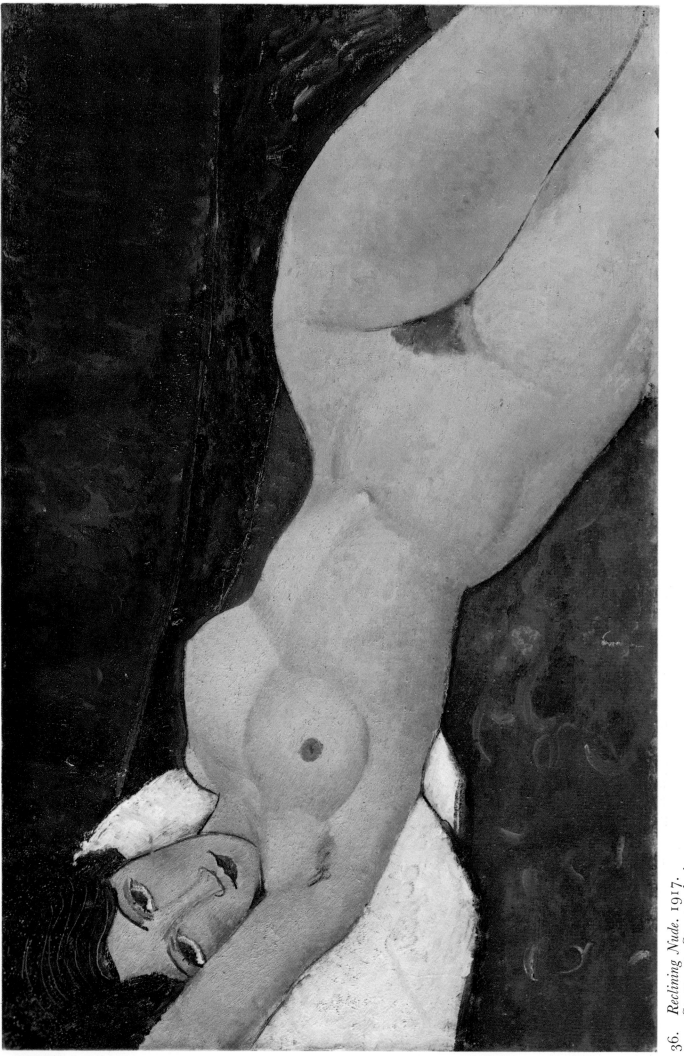

36. *Reclining Nude.* 1917.
Stuttgart, Staatsgalerie

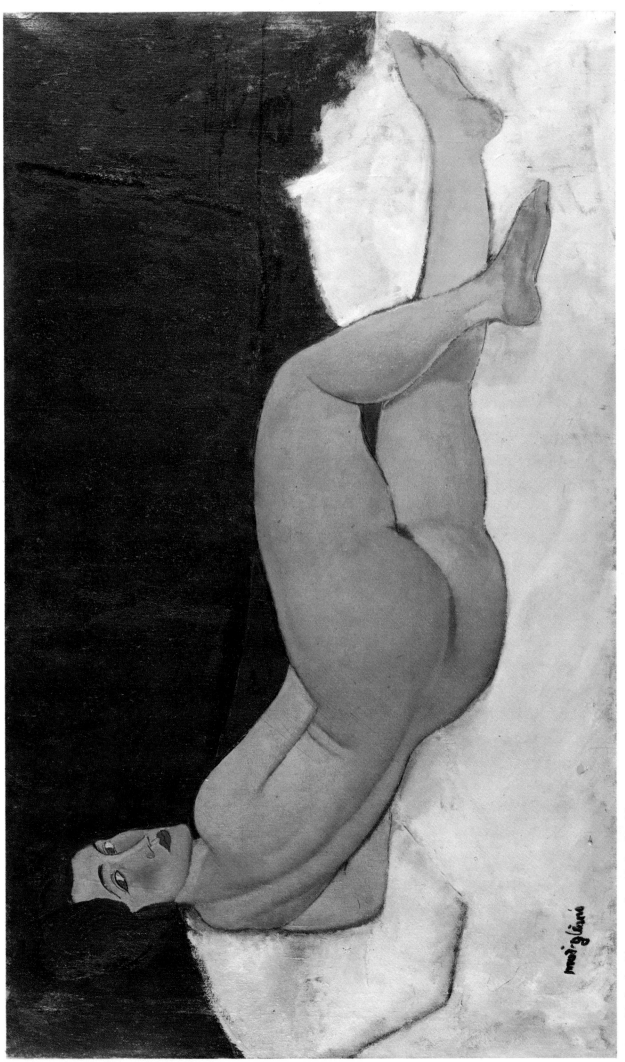

37. *Nude, looking over her right shoulder.* 1917.
Private Collection

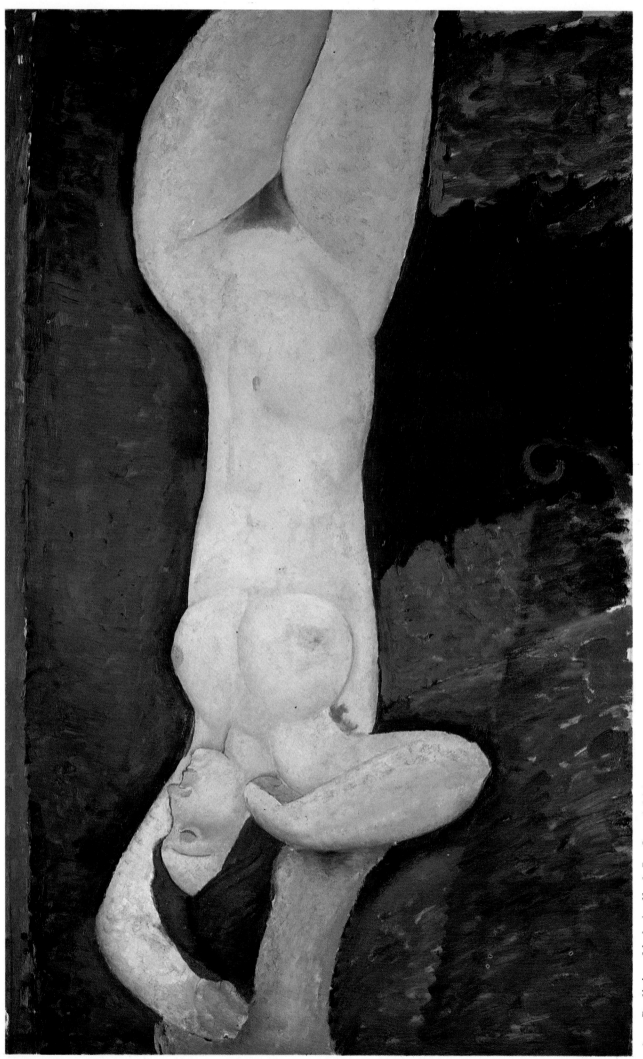

38. *Reclining Nude* (called *Le Grand Nu*). 1917.
New York, Museum of Modern Art (Mrs Simon Guggenheim Fund)

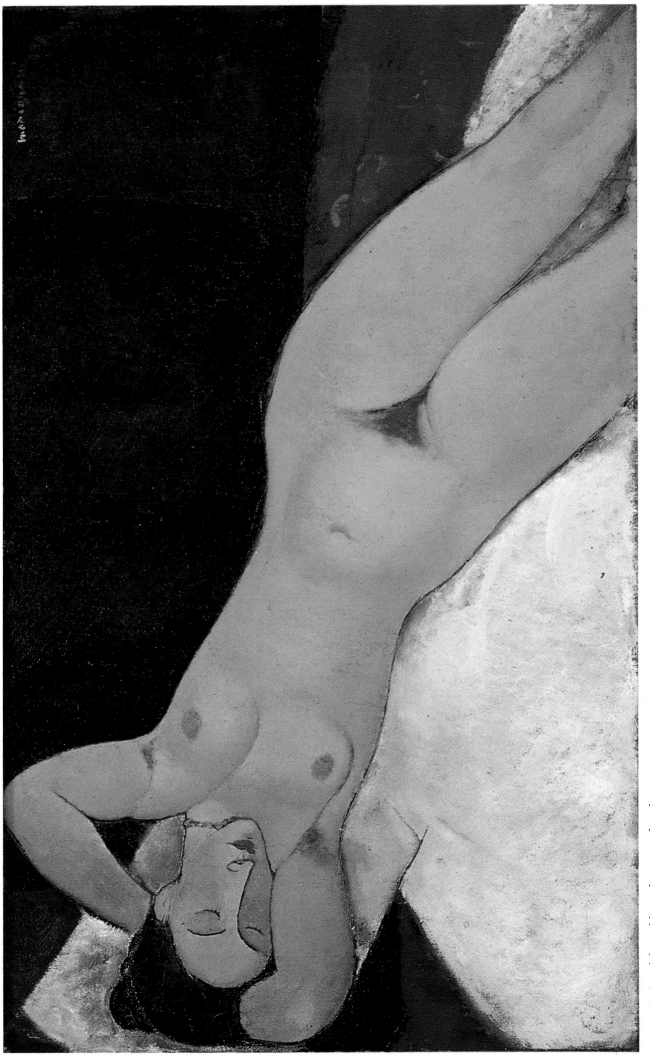

39. *Nude with necklace, her eyes closed.* 1917.
New York, Solomon R. Guggenheim Museum

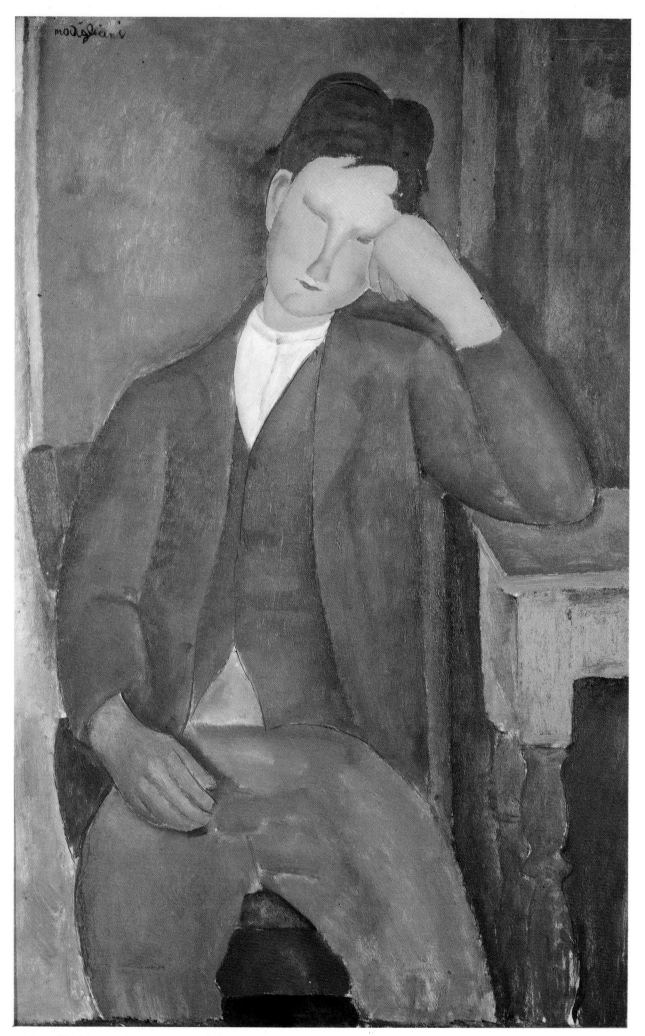

40. *The Young Apprentice.* 1918.
New York, Solomon R. Guggenheim Museum

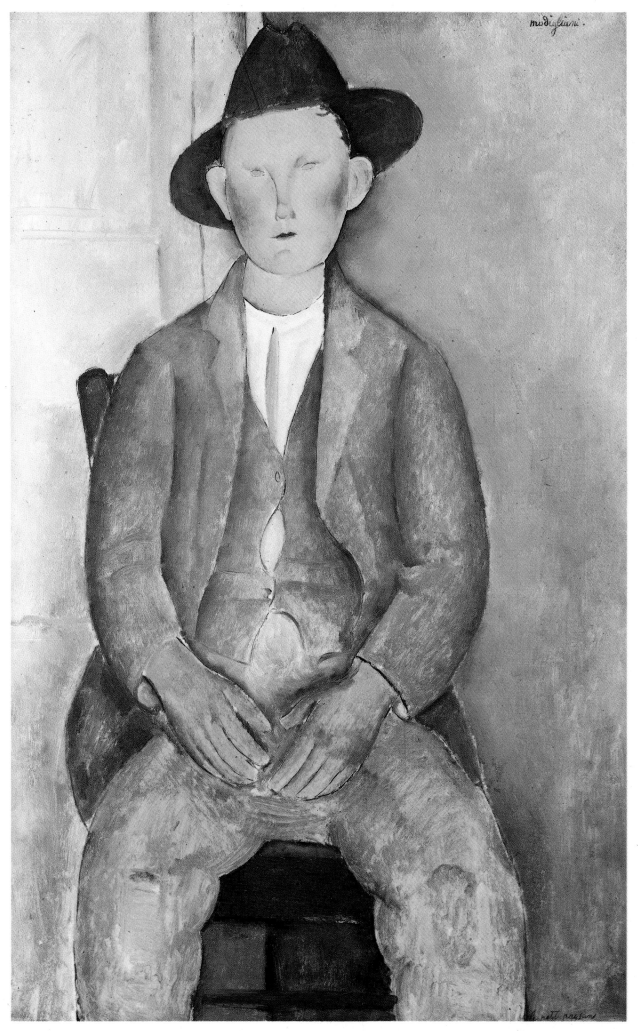

41. *The Little Peasant.* 1918.
London, Tate Gallery

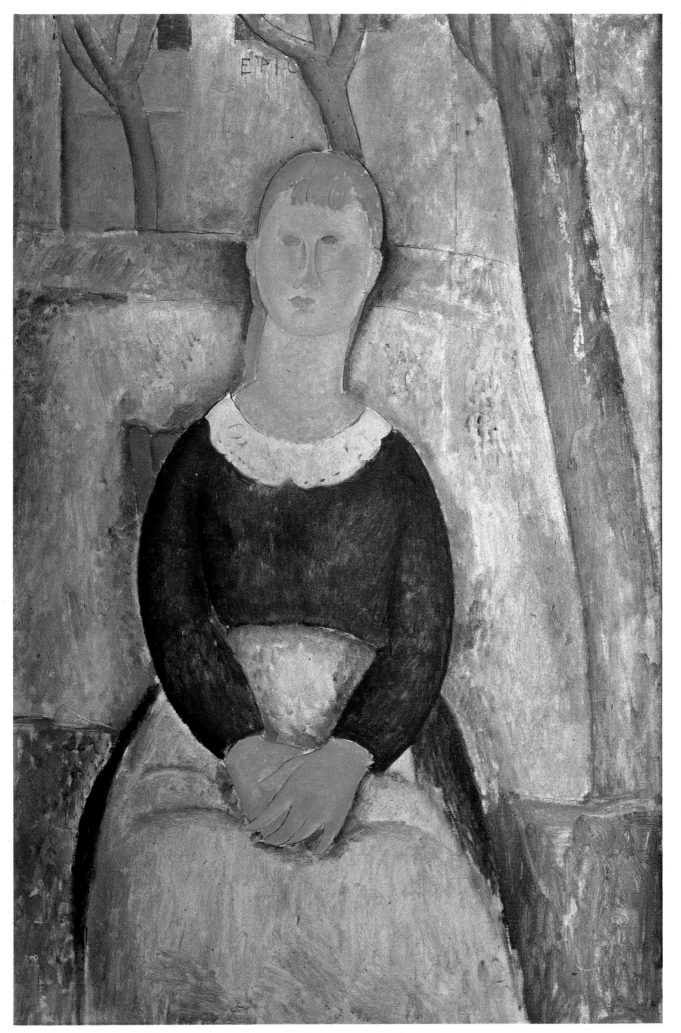

42. *La Belle Epicière*. 1918.
Private Collection

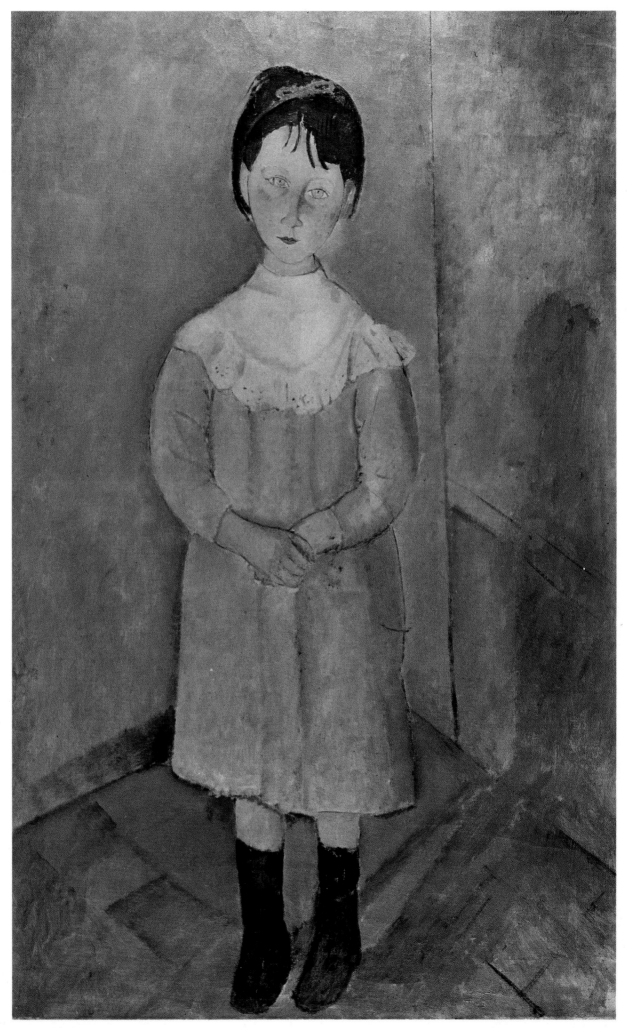

43. *Little Girl in Blue*. 1918.
Private Collection

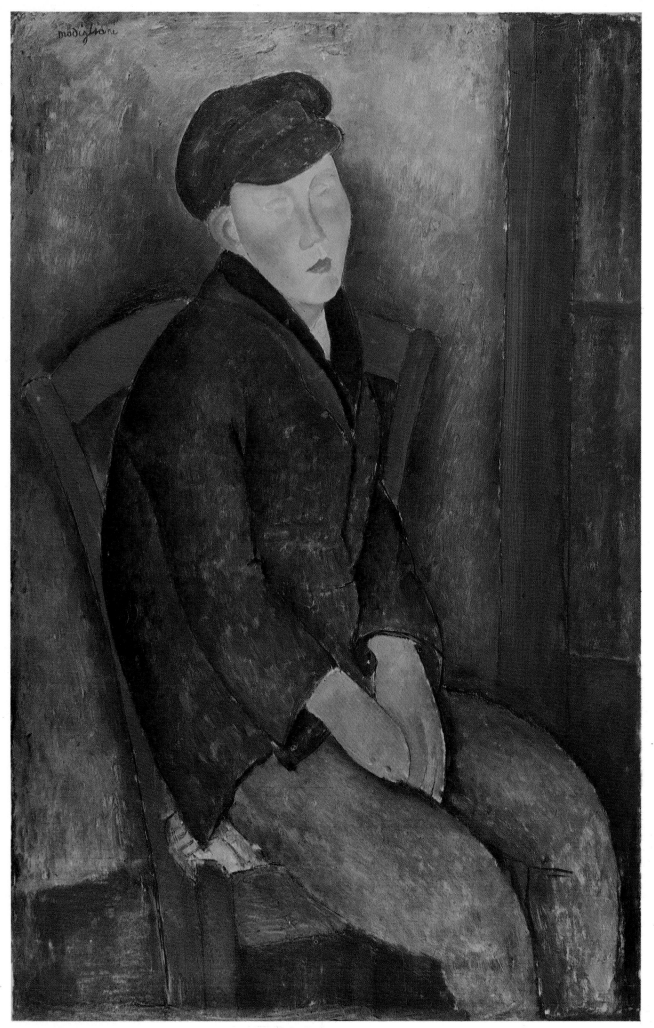

44. *Seated Boy with Cap.* 1918.
Private Collection

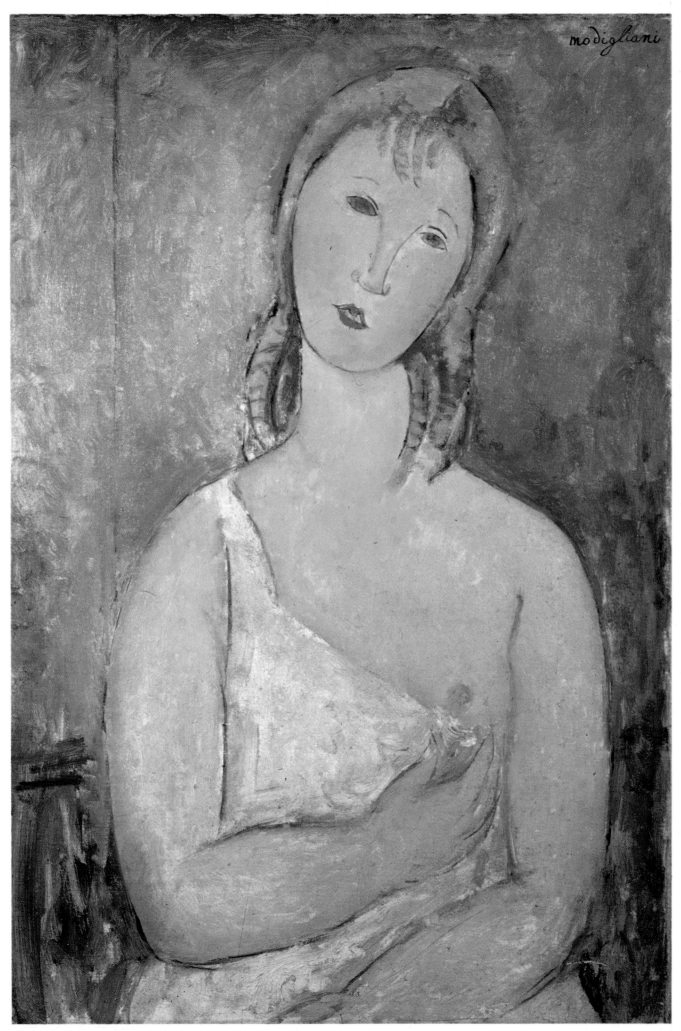

45. *Girl in a White Chemise*. 1918.
Private Collection

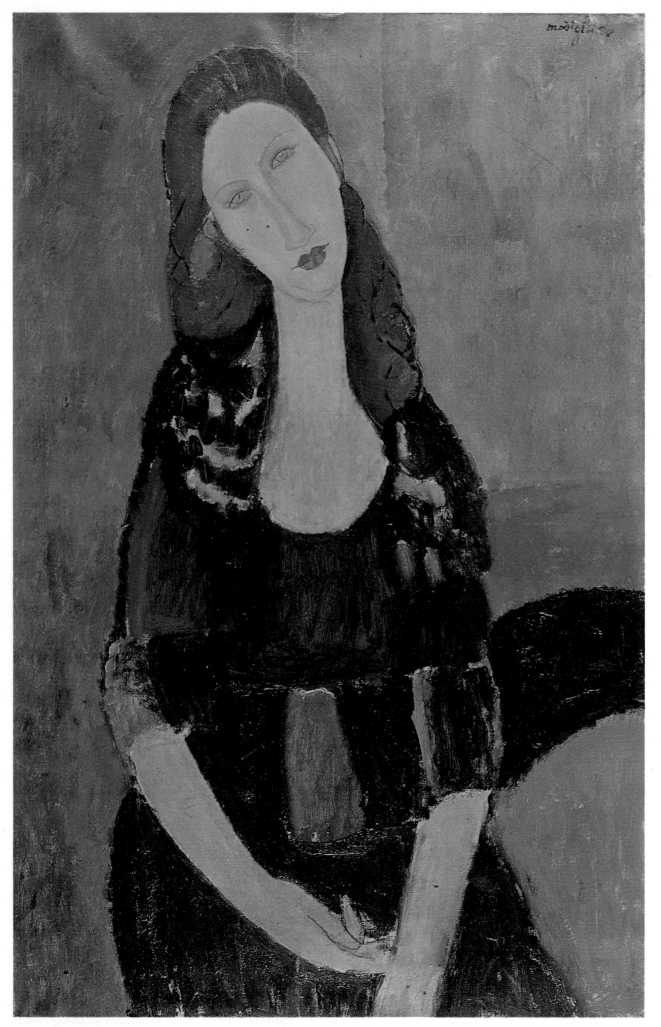

46. *Jeanne Hébuterne*. 1918.
Private Collection

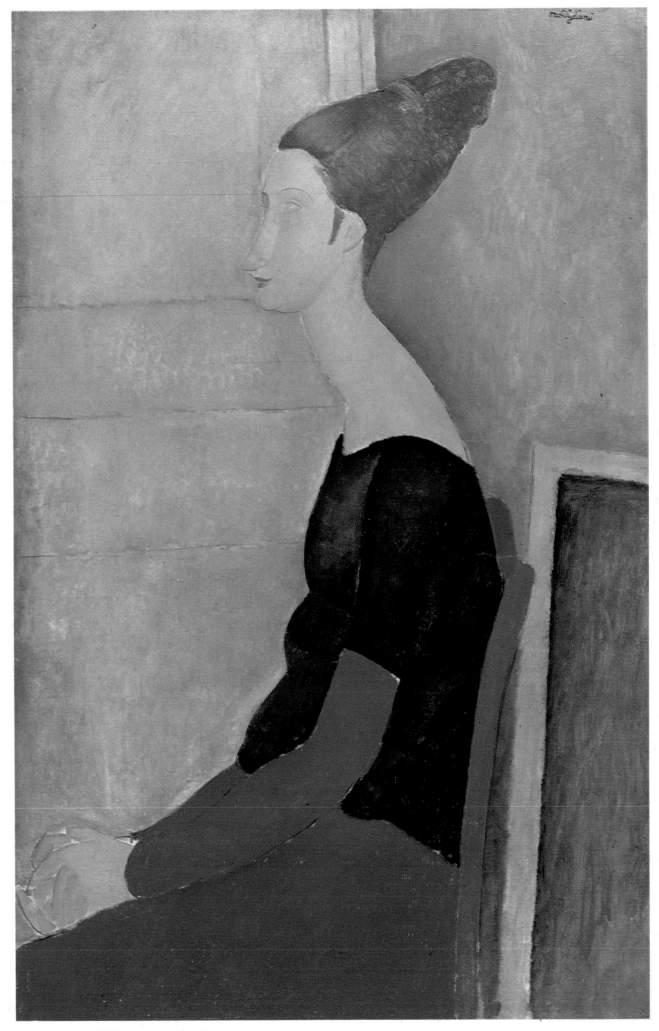

47. *Jeanne Hébuterne in Profile.* 1918.
Private Collection

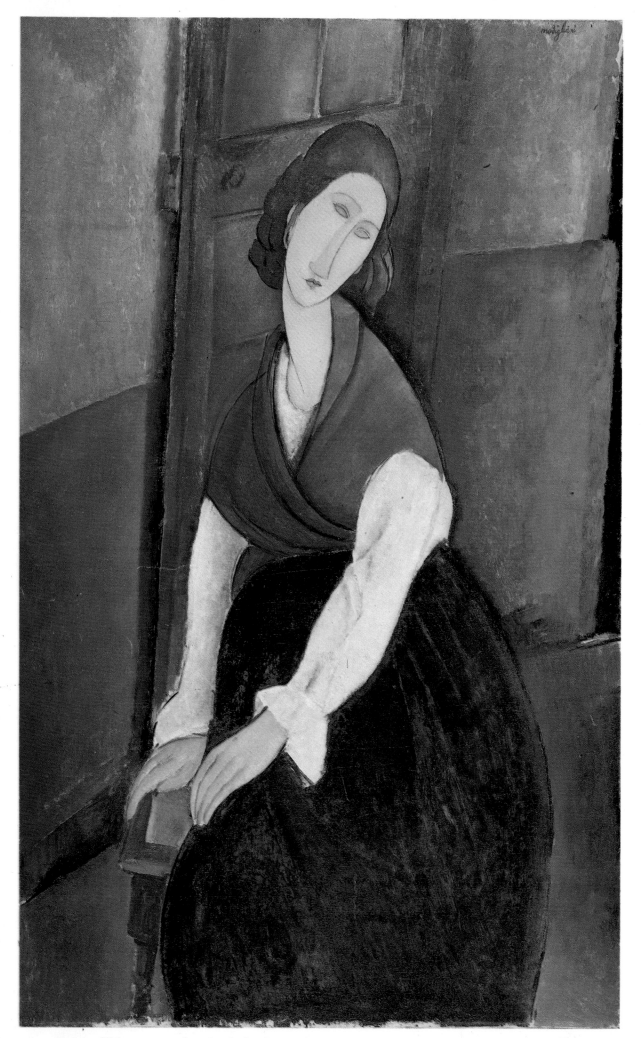

48. *Jeanne Hébuterne, a door in the background.* 1919–20.
New York, Sotheby Parke Bernet Inc.